Improve Learning
by **Building**
Community

*Dedicated to Bridget Daresh, a teacher creating communities
in her classroom each day,
and
Rebecca Lynch, a student contributor to the community
in which she learns each day.*

Improve Learning by Building Community

A Principal's Guide to *Action*

John C. Daresh
with Jane Lynch

Skyhorse Publishing

Skyhorse Publishing books may be purchased in bulk at special discounts for sales promotion, corporate gifts, fund-raising, or educational purposes. Special editions can also be created to specifications. For details, contact the Special Sales Department, Skyhorse Publishing, 307 West 36th Street, 11th Floor, New York, NY 10018 or info@skyhorsepublishing.com.

Skyhorse® and Skyhorse Publishing® are registered trademarks of Skyhorse Publishing, Inc.®, a Delaware corporation.

Visit our website at www.skyhorsepublishing.com.

10 9 8 7 6 5 4 3 2 1

Library of Congress Cataloging-in-Publication Data is available on file.

Acquisitions Editor: Debra Stollenwerk
Associate Editor: Julie McNall
Assistant Editor: Kimberly Greenberg
Production Editor: Jane Haenel
Copy Editor: Terri Lee Paulsen
Typesetter: C&M Digitals (P) Ltd.
Proofreader: Sarah Duffy
Indexer: Wendy Allex

Cover design by Scott Van Atta

Print ISBN: 978-1-63450-326-6
Ebook ISBN: 978-1-5107-0099-4

Printed in China

Contents

Preface **ix**

Acknowledgments **xiii**

About the Authors **xv**

1. It All Begins With You **1**
 General Information About Educational Platforms 3
 A Normative Use of a Platform 7
 Returning to Motley Elementary School 11
 Points for Practice 12
 References 12

2. Creating a Shared Vision **13**
 Developing a Vision 16
 Articulating the Vision 17
 Implementing the Vision 19
 Monitoring the Vision 21
 Creating a Vision: Returning to Carpenter Middle School 23
 Chapter Summary 23
 Points for Practice 24
 References 24

3. Foundations for Community Building **25**
 Definitions 26
 Operationalizing Community Beyond Structure 33
 Returning to the Administrative Team at
 Ridgmoor Middle School 37
 Chapter Summary 38
 Points for Practice 39
 References 39

4. Focusing on Culture Is More Than Good Manners **41**
 On Climate and Culture 43
 Development of Culture and Climate Research 45

Putting the Theory Into Practice 49
Returning to Manchester 55
Chapter Summary 57
Points for Practice 58
References 58

5. Studying Your External Environment **59**
Analytic Framework 62
Historical Thumbnail for the Riverport Community
 and Hilley High School 62
Structural Dimension of Riverport 64
Human Resource Dimension of Riverport 66
Political Dimension of Riverport 68
Symbolic Dimension of Riverport 70
Back to Pete 72
Chapter Summary 72
Points for Practice 73
References 73

6. Working With Community Groups and Parents **75**
Parent Concerns 78
Community Concerns 85
Returning to Cheshire School 87
Chapter Summary 88
Points for Practice 88
Reference 89
Additional Suggested Resources 89

7. Seeing Your Invisible Heroes **91**
Security Staff 94
Office Workers 97
Custodial Staff 101
Food Service Workers 104
Chapter Summary 107
Points for Practice 107
References 107

8. Services in the Community **109**
Students in Physical Danger 111
Drug or Substance Abuse 113
Student Mental or Physical Health 115
Family Turmoil 116
Returning to La Casa Blanca Schools and
 Bustamente Elementary 118

Chapter Summary 118
Points for Practice 118

9. Support From Central Administration **121**
What Makes It Hard to Change Schools? 124
Key People to Keep Informed 126
Chapter Summary 130
Points for Practice 130
References 131

Index **133**

Preface

The purpose of this book is to provide beginning and veteran school principals with a practical, how-to guide to help you transform your school into an effective learning community. It may also be helpful for individuals who are preparing for a future career in school leadership and who want to create schools that are truly focused on making the needs of students the center of all who work in and around schools.

In our view, a learning community exists in a school when the talents, skills, insights, and abilities of all who work in and around that school are focused on a single, unifying task. That task is always the improvement of learning by every student enrolled in a school. It is the responsibility of a leader who wishes to create a learning community to recognize the knowledge and talents that exist in all of those who work in a school and also the potential contributions that can be made by parents and community members surrounding the school. After these attributes are acknowledged, it then becomes a task to focus skills and abilities on improving learning for all.

The past 25 years have seen a great deal of literature describing the most effective strategies that should be used in leading organizations toward greater effectiveness. Two of the issues that are repeated consistently in all work on this subject are the importance of an effective leader and the importance of understanding the nature of community in the organization. The work of Tom Peters and Robert Waterman in the early 1980s indicated that the best organizations have the best leaders. In a similar vein, the work by Peter Senge throughout the 1990s has made it clear that the more that a sense of internal focus toward a common vision can be linked with a harmonious relationship with an external environment, the more likely it will be that an organization will achieve success by creating community. The ideal is clear. This book is written to give insights into the ways that you as the leader can take the ideal to a practical level. Senge refers to the importance of systemic thinking (realizing the interconnections of many people who see the "whole" and not just "parts"). Leadership and community building are important ingredients in a huge,

multinational organization, a hospital, or more to our interests, a school. The job of an effective principal is to find the talents that are needed to realize the vision of a school where all children learn. This is truly the driving force of any school as it interacts with many different individuals and groups. This book will help you address and overcome common barriers to creating communities in many schools.

School principals today face many challenges. At the same time, they are limited by a reality faced by all leaders who seek to improve their organizations. Each day has only 24 hours and at times, it seems that the expectations facing school leaders is based on a 25-hour (or more) clock. The issue of professional overload of principals is certainly an increasingly serious concern for all school leaders. As a result, the call for leaders to commit themselves to the creation of learning communities might be viewed as unrealistic. Our effort in this book is to assist you in your efforts to transform the culture of a school from one where isolation among people reigns to one where people work together to achieve common goals for learners.

ORGANIZATION OF THE BOOK

Through the chapters in this book, we look at many of the issues and people that can be recruited to help you in your transformative efforts. Chapter 1 begins with what may well be the most critical actor to be involved with promoting any significant change in a school—you as the leader. It specifically centers on the need for a leader to become attuned to her or his personal values as they relate to the principles of developing a sense of community in a school. Chapter 2 builds upon the issue of the values of a leader as it lays out the steps for creating an effective mission statement derived from a leader's vision of a school focused on shared values. Chapter 3 presents a brief review of some of the thinking that has gone into the current creation of efforts to promote community development in schools.

Chapter 4 explores how to create a culture that promotes community building and collaboration. Using the "Four Cs Model" for analyzing culture, this chapter shows leaders how to move staff and others toward a goal of collaboration. Chapter 5 focuses on the impact of the external community—parents, the neighborhood, community members—on a school and shows leaders how to analyze their community to understand its potential influences on the practices of the school. Chapter 6 offers insights into effective strategies to increase positive involvement by members of the external community to work with parents and others with a

direct interest in what takes place in your school. Another group often forgotten in discussions of building community in schools is considered in Chapter 7. This group is collectively described as the invisible heroes in your school, and it includes such community members as custodians, security officers, office staff, and food service workers who need to be included as important contributors to your school community. In Chapter 8, we look at the importance of increasing your awareness of a variety of social service agencies which exist in your community and which may provide numerous needed services to your students and their families. Finally, Chapter 9 suggests the ways in which you might be able to work with key members of the central administration in your district who need to be included in your efforts to bring about change to a learning community.

UNIQUE FEATURES OF THE BOOK

The overall goal of this book is to provide practical strategies and tips to assist you in your work of creating a more effective school. Each chapter begins with a **brief scenario** based on actual experiences we have witnessed over the years in real schools by real principals and others. This short case is meant to illustrate some of the fundamental issues that face a leader in terms of the topic for each chapter. No real names are used because the situations described, while based on real events, are but composite representations of a variety of behaviors and events that we have witnessed at different points in our careers. Next, there are **Points to Ponder,** inserted at various points in each chapter to promote some additional reflection on your part regarding the practical ways in which ideas presented in each chapter may be implemented in the reality of your school. **Tips for Practice** help you consider strategies that you may wish to follow in the unique reality of your own school as you move toward creating an effective learning community. Finally, summarizing each chapter are **Points for Practice,** which highlight key chapter concepts that are critical to building effective learning communities.

We wish you well in your important work to provide students with the best quality of educational programs available. We know that your time is limited and so are other resources, but we hope that what you read here will help you serve learners even more effectively in the future.

Acknowledgments

As we were engaged in the final preparation of this book, a great tragedy occurred when a good friend and supporter of our work, Professor Jorge Descamps of the University of Texas at El Paso, lost his long battle with cancer and passed away. The hundreds of mourners who came to spend a few last minutes with Jorge were strong testimony to the extent to which one individual educator could, through his care of others and dedication to helping schools serve learners, be more effective if one never forgets the human dimensions of leadership. Dr. Descamps will long be remembered as a friend to educators and education, and this work is a reflection of many of his core values of how schools should function.

We have been blessed through the modeling and suggestions offered by other caring and dedicated colleagues. Among these have been Richard Sorenson, Zulma Mendez, Teresa Cortez, Rodolfo Rincones, Don Schulte, and many other university colleagues past and present who have been supportive of the work that we have undertaken here. In England, we acknowledge the ongoing support of Tony Billings, Brian Hardie, and Glynn Kirkham as individuals who have assisted both of us in our efforts to define ways of helping students and teachers learn together.

We thank our colleagues at Corwin for providing us with the guidance and, at times, the reminders of deadlines and requests to add a bit here and a bit there to make this book into a useful resource for beginning, experienced, and aspiring school leaders who will become school principals and headteachers across our two countries. We note particularly our colleagues at Corwin, Debra Stollenwerk, friend, confidante, and task master in this writing activity, and her most appreciated colleague out in California, Julie McNall.

Our thanks to all.

JD and JL, August 2009

About the Authors

John C. Daresh is professor of educational leadership at the University of Texas at El Paso. Over the years, he has held faculty or administrative appointments at the University of Cincinnati, The Ohio State University, the University of Northern Colorado, and Illinois State University. He has also worked as a consultant on high school reform and on administrator professional development for universities, state departments of education, national and state professional associations, and individual schools and districts across the United States and also in Barbados, Canada, France, Holland, Israel, Turkey, South Africa, and Taiwan. By far, the bulk of Dr. Daresh's international service has been in the United Kingdom, where he served as an advisor and trainer for the School Management Task Force that developed and promoted support programs for beginning headteachers, the National College for School Leadership, the Welsh Office of Education, the North West Network for Diploma Development in Cheshire, Manchester Metropolitan University, the University of Lincoln, the University of Hull, CREATE Consultancies, and literally dozens of Local Education Authorities and individual schools across England and Wales.

Dr. Daresh recently completed three years of service as the lead consultant on principal mentoring programs for the Chicago Public Schools, as that megadistrict was faced with the challenge of bringing in mostly inexperienced principals to serve in many of the school system's elementary and high schools.

Jane Lynch currently serves as the faculty leader of the Department of Business, Information Technology, and Enterprise at All Hallows Catholic College in Macclesfield, Cheshire, England. Prior to this appointment, she served as a teacher at Sandbach High School in Cheshire. Her route to the field of education did not follow a traditional path. Her undergraduate degree at Keele University was in law and economics, resulting in a career as a solicitor supported by postgraduate study at Christleton Law College in Chester. Her interest in working more directly with young people led to a Post-Graduate Certificate in Education in Business Studies (Secondary) at Manchester Metropolitan University, where she later pursued advanced graduate work in educational management. She left the world of law and business to follow her strong interest in education, and the last 21 years of her professional life have been devoted to that focus.

Lynch's work in program development in business and enterprise has become increasingly recognized across England, where she has been invited to serve on a number of panels and committees seeking to forge stronger links among schools and the world of business. She was recently provided with a leave from her work at Macclesfield to support educational program planning with the Cheshire County Educational Office. She has also continued her national role of participating in numerous projects dedicated to developing young people's employment skills. She serves as a consultant in enterprise education in Cheshire; as the leader of the Northwest England Business, Administration, and Finance (BAF) Diploma Network; as the Enterprise Learning Partnership coordinator for Cheshire and Warrington; and as the chair of the BAF Diploma County Forum.

Lynch began her work with John Daresh while enrolled in graduate work at Manchester Metropolitan University, where she studied the use of mentoring as an instructional device to prepare teachers for educational leadership. More recently, she and Dr. Daresh collaborated on an international study of customer service in private industry as part of her work in developing the BAF Diploma.

It All Begins With You

1

Jane Clancy sat quietly for the 45-minute presentation by the guest speaker at the "Beginning of the Year Kick-Off" principals' meeting for the Lemon Peel Local School District. Jane had been waiting for this day to arrive ever since she had been handed the keys to Elvira J. Motley School, a preK–6 elementary school in one of the wealthier areas that make up the Lemon Peel district. Although she had nine successful years as an assistant at two other elementary schools, this would be her first assignment as a principal, and she was looking forward to meeting the challenges of leading a reasonably effective school toward recognition as one of the best schools in the district, if not the whole state. She firmly believed that she could accomplish her goal within the next two years, but it would take a lot of time and many long hours. As a result, she was only half-heartedly listening to the presentation being made to the assembled administrators.

The speaker was Dr. David Delacourt, a recently retired principal and superintendent who, as a principal, had done a superb job of taking his school from the status of being a good local school to becoming a nationally recognized "lighthouse" for all schools across the nation. Later, when he became the superintendent of his district, he made use of what he had learned in one school and applied the same vision to a school district with 18 individual schools that had recently won an award by the U.S. Department of Education as the "Most Effective School District" in the United States. Dr. Delacourt noted in his closing comments that the secret to the success of his school and the entire district was really much more simple than most people realized. What he realized one day as a relatively inexperienced principal was that "all the money, all the time spent, and all the hard work" in the world would not transform a school as powerfully as would a much less flashy strategy that did one thing: He believed in the people in his school. That belief fed another strategy that yielded great success for years, and then became the cornerstone for his work as a superintendent. The belief in the people inside and outside of schools leads naturally to the establishment of a powerful foundation, namely community. He ended his presentation

which included data concerning dramatic changes in a school and district after his philosophy had been translated into action. "I suddenly discovered that I truly believed that no school will ever be better than its people. If you believe that, you will find greatness."

Jane heard the last few sentences and laughed to herself. Her new school was well known as a good school because it had teachers who "knew their stuff." In her mind, all the advice of working to build a school on the strengths of each staff member, teachers as well as classified staff, was wonderful for speeches, but not the way good things will happen in reality. She had her own simple solution to school improvement: Build on your strengths. She would spend her first few months finding out the few exemplary teachers who probably worked in the school and showcase their talents and practices as models for everyone else to follow. And if people did not follow the stars, there would be changes made as soon as possible. After all, her superintendent had made it quite clear that she was empowered to do whatever it took to make sure that her school became as good as it could. And Dr. Delacourt's notions of involving everyone associated with a school as a partner was just so much fantasy that would never have much real pay-off. After all, she was chosen to lead a school, not serve to make people happy all the time.

Points to Ponder

- What is your reaction to this scenario? What if you were a classified staff member at Elvira J. Motley School?
- How would you describe the values of the new principal at Motley Elementary School? Do you personally agree or disagree with her views?
- How do you assess the value of ideas presented by Dr. Delacourt at the principals' meeting?

One of the most important parts of any leader's background and skills is his or her value orientations. As often noted by many analysts of effective leadership in any organization, what the leader believes and his or her values will ultimately define the reality of practice in an organization. Without a clear understanding of what you believe, it will be next to impossible to speak authoritatively about the future direction of your school. Simply stated, if people do not know what the leader believes, how can they follow?

Returning to the opening scenario for a moment, it would appear highly unlikely that the incoming principal of Motley School will be devoting

much time or attention to a sustained effort to create a sense of community in her school. Like many things in the field of education, even with inspiration offered by ardent proponents of new ideas or practice, good practices are destined to die a quick death because there is little or no heartfelt support for the new idea. It appears that Jane Clancy will spend a great deal of time supporting her best teachers, but they may be the only people in which she will invest much time during the next year as she tries to move her school from being *good* to *great*. And it also appears that she has little inclination to involve many other people in guiding her actions.

Points to Ponder

- In your judgment, what might the short- and long-term consequences be in a school where Jane Clancy's perspective was guiding action?
- What course of action would you follow if you were the principal who came to Motley Elementary School after Jane Clancy left?

In this chapter, we look at the ways in which your work as an aspiring or beginning educational leader may be made more effective through a review of personal assumptions and subsequent translation of personal philosophy into a broader vision of an effective school. Developing a clear statement of your personal educational philosophy is an important part of creating a culture for successful practice. While it should be clear throughout this book that there is an underlying set of beliefs about the inherent value of working toward the creation of a broad-based community, the choice of accepting that belief system is entirely up to you as a principal. But there is an absolute value to be found in a leader sharing an individual philosophy as a part of action planning and vision building that will make even a very good school better.

GENERAL INFORMATION ABOUT EDUCATIONAL PLATFORMS

The educational leader's platform, developed by Sergiovanni and Starratt (2007), is a model designed to help professional educators assess their views in a straightforward manner, akin to the platform statements made by political candidates in an election campaign. The major difference between a politician's and an educator's platform is that the latter is

Practical Tips

Preparing a Statement of Personal Values

There is a great deal of research indicating that effective leaders are clear about their personal values, beliefs, and assumptions. Many school districts across the United States now ask applicants for administrative positions to include a statement of personal beliefs along with a letter of application and the district job application form. Here are some tips to assist you in preparing a statement of personal values:

- **Be honest.** The statement of personal views is not an academic exercise. It should convey your own most important beliefs about schools, students, and schooling. The more honest you make the statement, the more helpful it will be for the school district and also you to determine if the job offered is the job you want to do.
- **Provide examples.** Actions speak louder than words. Remember that for every statement you write about your personal beliefs, an interviewer might ask for a concrete example of how you have actually behaved in a way consistent with your espoused beliefs.
- **Seek the counsel of a trusted friend or colleague.** Before submitting your written statement of values and beliefs, you should ask someone whom you trust to read your statement and critique according to the question, "Is the person described on this paper the person I appear to be in reality?"

structured to communicate the educator's deepest and truest beliefs, attitudes, and values, even if these are contrary to the sentiments of the voters and other members of the public.

There is no single, perfect format for an educational platform. For example, Barnett (1991) suggested that a platform may consist of a written statement which articulates an educator's views on issues ranging from desired student outcomes to preferred organizational climate to expectations for community involvement in schools. Sergiovanni and Starratt's model (2007) for formulating an educational leader's educational platform includes 12 major elements. Ten of these deal with general educational themes, and as a result, they can serve as the basis for any professional educator's platform. The last two are linked more directly to the role of a formal school leader.

The platform questions proposed by Sergiovanni and Starratt (2007) are excellent prompts to help any leader carry out a comprehensive personal reflection on a number of issues that are related to what constitutes "quality" in a principal's mind. However, as someone who is preparing to start an administrative career, or one as an assistant principal or a beginning principal, you probably have so much on your plate at this time that reflecting on so many ideas and issues is not likely an activity that you want to tackle right away. In the following section, brief excerpts from platforms written by principals and teachers follow each "plank" of what are really some of the key issues that you might wish to include in a platform early in your career.

1. The Major Achievements of Students This Year

The major achievements I would hope to have my children display by the end of the year include both academic achievements and personal achievements. (Teacher)

2. The Leader's Image of the Learner

Children are unique. Therefore, their ability to acquire and retain new knowledge and skills is unique. (Teacher)

Educators see students as individuals who want to gain knowledge or understanding through study, instruction, and experience. Adjectives that describe the learner are responsible, enthusiastic, inquisitive, attentive, hard working...and the opposite of each objective as well. (Principal)

3. The Leader's Image of the Teacher

Teachers with a clear mission have a deep underlying belief that students can grow and attain self-actualization. Teachers believe that they have something of significance to contribute to other people, especially students, and believe with every fiber that they can "make a difference." (Teacher)

Since teachers work directly with our children, I expect that teachers can do many things, from modeling commitment to high standards and moral values, to being a dispenser of knowledge and translator of culture, to being a friend, adviser, and counselor. In short, I believe that teachers can and often do work miracles. (Principal)

4. The Preferred Teacher-Student Relationship

The relationship established between the teacher and the student has a profound effect upon the child's ability to function and learn to his or her optimal level.... It is important for the teacher to understand that each child is unique and that a teacher's expectations for one student might not be the same for other students. (Teacher)

The interpersonal relationships that occur and the bonds that are formed between teacher and student are special.... Students look up to educators with admiration. Educators who give praise and encouragement might be the only positive influence in some students' lives. It is not surprising that strong bonds and relationships are formed. (Principal)

5. The Preferred School Climate

An atmosphere of trust and safety must be created within a classroom. Within this environment, each child's unique needs and interests can be met. (Teacher)

The school climate is affected by educator attitudes, how staff members relate to administration, the amount of collegiality that exists, teacher-student relationships,

(Continued)

(Continued)

and school-community relationships. I believe that attitudes might be the key to a positive climate. (Principal)

6. The Purpose or Goal of Leadership in Schools

The focus of educational leadership should be to maximize children's learning. This is accomplished by directly improving the quality of a teacher's instruction within the classroom. An educational leader, therefore, is a person whose responsibility and desire are to help teachers and capitalize on their strengths. (Teacher)

I think the real goal of an educational leader should somehow be to identify the strengths that people have and build on those. If people make mistakes and need help, that should also be a part of the educational leader's role. Dealing with mistakes can be done in a way that promotes growth and professional development. (Principal)

None of the excerpted statements found in the platforms of several different teachers and principals are the right or correct things to say in statements such as these. And the format for the platform provided is but one to engage in this exercise. Others who have engaged in the platform preparation process have written their beliefs in ways much different than the model shown here. The purpose of developing and sharing platforms is not an exercise of doing a single written activity and then leaving it alone. It is meant to be something that promotes ongoing dialogue in a school so that everyone can gain insights into the values that are present and that may drive different practices and approaches by members of the school community. For example, in the illustrated platform statement of both the teacher and the principal, it is evident that there is strong consistency of the image of the principal and other leaders taking on the responsibility for providing professional development. Other similar insights might be derived from reviewing individual statements of belief.

Points to Ponder

- As you read over the examples above, what might a reader of these individual statements believe about the mission of schools where the authors of these comments worked?
- Would the school implied through the collected values be the kind of school in which you would like to work?

A NORMATIVE USE OF A PLATFORM

The exercise of platform development described so far suggests that there is a value to be derived in school by simply asking people to think about personal values (Daresh, 2007). By the way, it should be noted that the discussion of personal values is not something that may be limited to the teachers and the campus administrators. Everyone who works in a school may be encouraged to share their values and beliefs about any or all of the enumerated areas included in a platform.

The purpose of this book in total, however, is to suggest that there are characteristics of a particular approach to schooling that call for underlying beliefs to exist, particularly by the leader. Simply stated, as shown in the opening scenario of this chapter, if you believe that there is no real value in creating a sense of community in your school, it will not happen. In this case, there are still no right or wrong things to believe. But there is a need to realize that a normative value exists here.

As you read over the kinds of issues that must be considered if a leader wants to develop a school community in a most positive sense, you must reflect on your personal responses to each item. Like Jane Clancy, you may think that being a good principal is quite compatible without any emphasis on bringing people together.

What Value Do You See in Creating a School That Functions as a Community, or Even as an Extended Family?

There is little doubt that there are increasing calls for effective organizations of all types—schools, businesses, hospitals, and so on—to adopt philosophies that indicate that they are functioning more effectively because they have chosen to follow the advice of ardent recent contributors such as Peter Senge (1990), Roland Barth (1990), Richard DuFour and Robert Eaker (1998), and many others. Each of these authors have suggested that when effort is spent in any organization to create a sense of community through the intentional focusing of resources of common goals, the result will always be increased productivity of members of the organization and, ultimately, high degrees of performance. That is the theory and fundamental belief of those who, like the fictional Dr. Delacourt in the opening scenario, propose that schools should adopt models of community learning.

While there are many true believers in the world of learning community development, there are many, perhaps including yourself, who are not quite as enthusiastic about this approach to improving practice in schools. There are those who truly believe that the principal of a school has much more to do than spend a great deal of time trying to bring

people together. As the principal in the first few pages of this chapter observed, there is a lot more to do than jump on some bandwagon.

What Is Your Attitude About Parental Involvement in the School? Is There Already Too Much Opportunity for Parents to Be Active Partners, or Not Enough Opportunity Available?

The vast majority of schools across the country indicate that they welcome visits from parents and other members of the community. In effect, they tell people that they are always happy to see a mother or father who takes time to come to a school to see how a child is doing. In fact, schools often advertise their willingness for parents to feel at home in their local schools. Often, there are signs posted on the front doors of schools saying things like, "Welcome, Parents! This is your school."

Events in recent years make it less likely that anyone, even a parent, can simply walk through the front door of a school and start walking around the halls, or walking into a classroom completely unannounced. From large suburban high schools like Columbine High School in the Denver area to tiny village primary schools such as the one in Dunblane, Scotland, many schools have faced the terror of unwanted intruders walking in and killing teachers and students at random. These are dangerous times, so even schools with a strong commitment to active parent involvement are more reluctant to simply allow complete access to the school. And increasing pressures at every level of schooling for increased attention to student achievement mean that it is less and less likely that teachers will simply keep their classroom doors wide open to any family member who simply wants to "watch what's going on in my child's classroom." Restrictions on access to any noneducational personnel are common.

But the practical need for security is not the issue that you need to consider before adopting a perspective consistent with community learning. The fundamental issue concerns whether or not you, as the principal, believe that parents are partners in the educational process of their children. There is a big difference between having "Meet the Teachers" or "Back-to-School" nights where parents are invited to come to the school cafeteria for cookies, punch, and polite introductions once a year, promoting a sense of the school valuing input from people who do (or should) arguably have the highest interest in what is taking place in their local schools. "Parental involvement," as measured by attendance at occasional meetings, is far different from parent engagement in the life of a school. As principal, you (and your values, beliefs, and platform) have a lot to do with choosing among possible answers to this issue.

How Important Is Broad-Based Involvement in Decision Making That Has Implications for Policies and Practices in All Parts of Your School?

Since the early 1990s, every state has mandated that school districts and individual schools create site-based councils, committees, and other groups that enable teachers, parents, and administrators to meet on a regular basis to make recommendations for the improvement of schools. This is a vague description of the actual conduct of these groups once they are created. In some cases, site-based councils are active and integral parts of the decision-making process that affects the lives and practices of teachers, students, and administrators of schools in a way that is consistent with the needs, interests, values, and beliefs of local neighborhoods, attendances areas, villages, or other areas of a school system. Operationally, however, local site-based groups often simply meet periodically to appear as if the state mandate for groups to gather is addressed. Not much occurs other than more opportunity for a few people to talk about what is going on in their local school.

The choice of how to make effective use of decision-making groups, whether mandated by state law or simply by local tradition, is largely a matter of your values and platform. Do you really believe that the activities and priorities of a school will be clarified and enhanced by involving people with diverse interests and attitudes to gather periodically, or do you have the attitude of one principal I knew who was anything but supportive of broad-based involvement when he observed, "I believe in shared decision making. As the leader here, I make all decisions and then I share them with anyone and everyone." The choice, again, is yours.

What, If Any, Is the Appropriate Amount of Involvement of Non-Certificated or Classified Staff in Your School?

Jane Clancy, the new principal at Motley Elementary School, clearly answered this question when she decided that her focus for school improvement would be to work exclusively with teachers. Not all teachers, necessarily, but rather the "best teachers."

If Jane's goal as a school leader is simply to increase the perceived effectiveness of her school by raising test scores, she probably has a reasonable strategy: Make certain that the most experienced and skilled teachers focus on improving one indicator of effectiveness, devote all available resources to help achieve that narrow goal, and you will probably succeed.

In reality, however, there is much more to the creation of an effective school than increasing scores on a statewide standardized achievement

test. While volumes can be filled with alternative descriptions of potential images of "good schools," there are many additional goals that can be followed in creating an effective educational experience for young people. And the way that you can begin to decide the proper goals for your particular school may be to "pick the brains" of more than those who are certified or licensed professional educators. Believe it or not, that list may include your clerical staff, security personnel, instructional assistants, food service workers, and even your custodial staff. While these individuals may not have college degrees or certificates from the state department of education, they have insights into what can be done to help children. Many of your "invisible" staff members have worked in schools for many years longer than you (or many other "official" educators on your team) have. In addition, they not only have ideas, they also have ways to add to the quality of learning experiences for your students. We know of one school where the head custodian regularly takes on the challenge of working with groups of high school students who are never likely to fit in with the traditional behavior of what might be expected of proper students. Kids who are turned off to schooling might be reeled in if an alternative vision of teaching could be found. To put it simply, there are many educators in your school—if you choose to find them and include them.

What Is the Appropriate Role of Agencies, Businesses, and Other Members of the School Neighborhood That Do Not Necessarily Have a Direct Stake in Your School?

"One of the greatest challenges we face in the United States is how to do something about the horrible condition of public education in this nation." Ridiculous hyperbole? Inaccurate? In our judgment, the answer to these questions is "Yes." I fully continue to believe something that I have believed throughout my professional career, and that is, despite the fact that there are some schools in trouble, the vast majority of public schools in this country do a remarkably good job of educating most children, most of the time. That is because most of the people who work in most of the schools are committed to ensuring that all children learn. But for the past 20 years or so, the state of American public education has been identified as a key talking point by politicians, ranging from local city council candidates to state office holders up through presidential candidates. It seems that public-school bashing has been developed as a regular message. And following on the heels of the bashing often come "solutions" from private corporations. Jack Welch of General Electric writes a book and provides significant financial support for the New York Leadership Academy to prepare new principals. Bill Gates provides millions of dollars

to support the improvement of high school education—after he writes a book. The rather powerful statement seems to be, "If only the school people would listen and learn from private industry. . . ."

Given this background, it is not surprising that many educators—teachers and administrators—are somewhat resistant to anything that suggests that schools should open their doors to the private sector. The numerous descriptions in negative terms have built walls between schools and many groups in their external communities. But the fact is, schools must connect with the outside world for many reasons. First, politically, public schools cannot alienate themselves from agencies that pay high taxes in many communities. Second, at least one function of schools is to prepare students for work in the future. It is critical to maintain effective working relationships with those who will eventually be called upon to employ our graduates. Third, and perhaps most important, there are many things to be learned by listening to insights of those who do not work in schools each day. This does not mean that everything every business representative touts must be adopted as absolute truth to "fix" schools. But as noted with the issue of involving noneducators within schools, it is worthwhile to talk with others to gain new insights. Again, however, the choice must be yours as a principal.

There are, no doubt, many additional issues that you might wish to consider in terms of your personal values, attitudes, and beliefs about practices that may have a direct impact on what is going on in your school.

Points to Ponder

- In your view, what are the greatest advantages associated with remaining open to the concept of developing community within a public school?
- Would you move forward with an effort to implement a sense of community in a school in which you serve as a principal (or hope to serve as a principal)?

RETURNING TO MOTLEY ELEMENTARY SCHOOL

What if Jane Clancy had not decided to turn off the model of community development for her new school? For example, had the opening scenario ended by saying that Jane was greatly impressed by Dr. Delacourt's presentation, and that she decided that she was sold on the idea of creating community at Motley Elementary School, what steps might she take to begin to use this concept as she moved in?

The remaining chapters of this book will attempt to answer these questions. Some background regarding the development of the recent

focus on school community building will be given, but perhaps more important for you as a principal will be the ideas that will be raised in chapters that deal with increasing communication with the private sector, parents, and your own internal school staff. Regardless of the information provided, do not lose track of the fact that any direction that a school follows will only be successful if the leader commits and supports the vision. It all begins with you.

POINTS FOR PRACTICE

- The foundation for all efforts to bring about necessary change and improvement of school practice is derived from the values of the school and its staff.
- The only way in which good things will happen in schools is if people in schools value that good things will happen.
- As the leader of a school, the principal—whether a beginner or a veteran—must set a tone in the school where discussions of values take place regularly and all points of viewed are honored.
- A powerful tool for promoting discussion and sharing of values is the educational platform activity.
- While sharing platforms is a very useful activity, it must be followed by commitment and action. Simply saying what you believe is only the beginning of an ongoing process of reflection that leads to positive outcomes.

REFERENCES

Barnett, B. (1991). The educational platform: Articulating moral dilemmas and choices for future educational leaders. In B. Barnett, F. McQuarrie, & C. Norris (Eds.), *The moral dilemmas of leadership: A focus on human decency* (pp. 129–153). Memphis, TN: Memphis State University, National Network for Innovative Principal Preparation.

Barth, R. (1990). *Improving schools from within: Teachers, parents, and principals can make a difference.* San Francisco: Jossey-Bass.

Daresh, J. (2007). *Supervision as proactive leadership* (4th ed.). Long Grove, IL: Waveland Press.

DuFour, R., & Eaker, R. (1998). *Professional learning communities at work: Best practices for enhancing student performance.* Alexandria, VA: Association for Supervision and Curriculum Development.

Senge, P. (1990). *The fifth discipline: The art and practice of the learning organization.* New York: Currency Doubleday.

Sergiovanni, T. J., & Starratt, R. J. (2007). *Supervision: A human perspective* (7th ed.). New York: McGraw-Hill.

Creating a
Shared Vision

2

Arnold Fletcher was happy to learn that he had been selected as the new principal of Carpenter Middle School. Carpenter has always been recognized in its community as a good school. From the perspective of parents, the school did a decent job of teaching basic information that would be needed by their children when they got to the local high school. And the students seemed to be well protected and safe. Others in the community were satisfied that the school was under control. The students did not do any damage to local homes and other property as they walked to and from school. And the teachers and administrators always seemed to be able to keep the lid on things. It was also a school which was kept clean and in good repair—issues that would ensure that local homeowners would continue to be able to sell their homes for top dollar. Students have always liked going to Carpenter because the teachers were laid back and never made any demands on the kids.

Arnold had, in the eyes of many, walked into a perfect school—as long as he did not do anything foolish by trying to change things. But he also knew that Carpenter was capable of achieving a great deal more than it had so far. While overall student achievement test scores for the school's Grade 7 and Grade 8 students appeared to be high (more than 90 percent of the students had performed at a level at or above state norms), the few African American and Hispanic students in the school were not performing at nearly the same level. He was also concerned by the apparent lack of parental involvement beyond the Grade 6 class. But the most significant issue he wanted to address was the overall climate of the school. Indeed, it was a quiet, orderly, and controlled school. But after spending his entire career in middle schools as a teacher, counselor, and most recently as an assistant principal, he found the tranquility of his new school to be so unusual as to be something that was already causing him some concern.

During the first week of the new school year, Arnold was immediately aware of differences between Carpenter and other middle schools in the district. Students seemed to march in and move to their assigned classrooms with little or no direction from staff. There was no running and no shouting. In fact, Arnold noted an almost eerie silence in the school despite the fact that more than 800 adolescents were back in school for the first time in nearly three months.

It was becoming easy to note the features of the school that had an appeal to the community and parents, as well as teachers. Students were orderly, well dressed, neat, and extremely well behaved. This was no regular school where a good part of the administration's day would be tied up with behavior management. Nevertheless, Arnold was not sure if he liked what he was witnessing. He decided to share his observations at the first full faculty meeting scheduled for Friday.

As the scheduled time for the faculty meeting approached, the new principal stood on the small stage in the front of the auditorium to watch the teachers file into the room. Their behavior seemed to parallel the actions of the students. There was no laughter, loud talk, or any of the kind of playful interaction Arnold had often seen displayed by teachers as they ended the first week back on the job at other schools. When everyone had entered the room and found a seat (usually with about two empty seats separating each teacher from any other staff member), Arnold moved to the center of the stage and looked at the faces around him. In most cases, this was a time to allow people to conclude their last bits of conversations with neighbors, but at Carpenter, the wait time was unnecessary. The principal began with the usual statements about how good it was to get back to work with students and teachers, and how he always looked forward to the beginning of each new school year. He made the expected comments about how happy he was to be able to work in such a fine school with a great reputation and with so many well-respected colleagues. At that point, he had planned to launch into an overview of the issues that he saw as critical concerns for the school. He had an overhead transparency with statements such as "Increase parental involvement," "Reduce differences in achievement among groups of students," and so forth. However, as he looked around the auditorium, he concluded that less talk from him would be better. He had to do something to engage the teachers more actively in the meeting, so he announced, "Ladies and gentlemen, I had planned on making a few of my own observations about some things that we need to address this year to improve Carpenter. But instead, I'd like to hear some of your ideas so we can start working together on *our* agenda."

The principal looked around the room and for the first time, he began to notice a few smiles appearing on the faces of some faculty members. Suddenly, a few hands popped up and Arnold eagerly called on people to begin sharing their personal thoughts.

"Mr. Fletcher," began one teacher, "I think we all know that there is some disparity here in terms of student achievement. The Anglo kids are doing pretty well, but we can't say the same thing about the Latino and African American students." Arnold smiled at hearing one of his central issues rise to the surface so quickly. He responded to the teacher by noting, "I think that issue is very clear from a quick glance at our student performance on the state test last year. What do the rest of you think we can start to do to address this concern?"

The question from the principal seemed to have had an almost magical affect on the majority of teachers in the room. There was a noticeable shift in the ways in which people were seated. Suddenly, they started to sit forward in their chairs and make direct eye contact with the principal. Of course, there were still pockets of faculty members who continued to sit back in their chairs and glance at their watches as if the next bus was about to pull up and they had to be on it. But hands were being raised around the

auditorium, and the principal could barely contain his happiness at turning over the meeting to his teachers. One person after another made comments that seemed as if they had already seen the overhead slide that he had not shown. "Parents never come here to school, and I think that may be because we've always made them feel as if they were intruding on our time." Another person simply stated, without the benefit of formal invitation, "The thing that really drives me crazy here is how the kids seem to be trained. I have three of my own kids at Casa Grande Middle, and I can't imagine them behaving like the little angels we seem to have here. I mean, it's nice not to spend all of my time disciplining the students, but at the same time it's weird." At that point, Arnold had a distinct impression that this could be a very good year.

Points to Ponder

- What would have been your strategy in leading the faculty meeting? If you had made use of the transparency slides, what might have been the effect on the teachers in the room?
- Now that Arnold has learned that his concerns about the state of Carpenter Middle School are shared by at least some of the teachers, what would you advise he do in terms of next steps?
- Not all the teachers in the auditorium identified problems at the school. If you were the principal, what would you do to make certain that you heard from all of the teachers?

As an educational leader, it is probably safe to assume that you want to be the leader of a good school. But before we get around to that, let us consider an even more basic issue: What is a "good school," at least in your own mind? The literature is filled with references that effective leaders are critical ingredients in effective schools (Brookover, 1981; Edmonds, 1979; Lipham, 1981). At the basis of any effort by a principal to promote quality in a school must be the leader's personal vision of what constitutes quality. In the current climate of accountability and high-stakes testing, it may be simple enough to say that "it's all in the numbers" and conclude that a "good school" is one where students consistently demonstrate learning through high test scores. But is that a sufficient enough indicator to suggest that a given school is actually representative of an educational program that addresses the learning needs of all students?

This chapter considers the ways an effective leader of a school can go about fine-tuning a vision of what effectiveness should be. Emphasis is placed on determining strategies the principal might use to discover how

Practical Tips

Creating Your School's Mission Statement

All sorts of modern organizations have displayed mission statements for customers to read. But if you ask employees about their particular organization's mission statement, very few people would be able to recall much, if any, of the details. Many mission statements, once written, are soon forgotten. Here are a few tips to keep in mind as you consider establishing your school's mission:

- **Take responsibility for the vision.** As the leader of a school, you are responsible for articulating the vision. The creation of a vision should be linked to your platform. It is not a collaborative effort on the part of stakeholders to create the overall goal.
- **Collaborate on the mission statement.** The mission statement is a different matter since it is here where you work with all in your organization to develop a strategy that will lead the school to your vision.
- **Create a dynamic mission statement.** The mission statement that you and your community create must be dynamic and able to react to changes in the school, its community, or society in general.

all members of the school community may be involved in this process of working toward the development of successful educational practice.

DEVELOPING A VISION

A critical responsibility of the leader of any organization is centered around the individual's ability to develop a personal sense of what he or she wishes to accomplish as a leader. In the preceding chapter, we considered the importance anyone should place in the clear articulation and sharing of a personal educational platform while serving as a principal, assistant principal, superintendent, or any other leadership role in education. While this activity will be useful in helping you to reflect on your personal goals, beliefs, and values concerning schooling, perhaps an even more critical issue related to your ability to work with others in determining an overarching vision for your school may be the following:

Points to Ponder

- What do we want this school to become?

While the articulation of a professional educational platform is a valuable individual process, you also have the duty as a leader to extend the logic of identifying core values and beliefs to a larger schoolwide level through the process of leading the school toward a common vision or "organizational platform." In the next section, information is presented concerning a potential strategy that may assist you as a leader in working with a school staff in developing a group vision.

ARTICULATING THE VISION

According to Lunenburg and Ornstein (2004), "Vision that reflects only a leader's view is bound to fail" (p. 355). The first step in establishing a vision in any organization involves the process of bringing together people who work in that organization, to do a bit of "collective dreaming." In essence, when a vision is established, it represents a collective value of what is the very best that can possibly happen. Some may even say that the best vision is something that is actually unattainable, although simply beginning the discussion of how to envision a desirable end state as a kind of unrealistic exercise in futility is not a good starting point. On the other hand, setting sights only on goals which may be attained with little effort is rarely going to move an organization onto greater accomplishments.

Often, the process of establishing a collective vision for a school might begin with general questions posed to the entire faculty, or at least to a critical mass of individuals who represent the diverse views of the larger group.

Points to Ponder

- Think about the kind of school you would want your own child to attend.
- Think about some of the things that would be seen in that school.

These questions serve as a kind of starting point for the discussion of a vision set for a school. First, they ask people to personalize the process. While it is relatively easy to talk about something in the third person, or as some sort of inanimate institution, asking people to consider something as personally important as their own child's education moves the discussion to a more emotional and powerful level. Suddenly, participants in the vision-building process are engaged in considering something with high stakes and important outcomes.

Inevitably, this opening question results in discussions that provide a rich description of the ideal school. Under most circumstances, participants move well beyond scientific or political statements regarding statewide achievement test scores or statistical data regarding dropout rates or the certification of teachers. Instead, what often appears at this first stage are statements such as "A good school is one where people show sincere care about each child as an individual," "The ideal school is one where everyone feels involved and respected," and so forth.

While the first step of the collective visioning process can involve a great deal of imagining and considering the very best scenarios, it is critical that the vision-building process moves quickly toward a more concrete, operational stage. Joel Barker (1995), the well-known futurist, has noted that a "vision without action is only a dream."

In the present day, schools cannot function effectively as dream worlds. As a result, the leader needs to continue the process by considering another set of questions about the characteristics of the ideal school.

Points to Ponder

- What are some of the behaviors of students that you might observe as you walked past classrooms? What about in the halls? On the playground? In what types of activities would you expect to see students engaged?
- What teacher behaviors would you expect to see in the ideal school? How would teachers act? What would you observe in interactions between teachers and students? What things do you think you would see in faculty meetings?
- What behaviors and practices would you expect of the principal and other administrators in the school? How would they interact with students? With teachers?
- What kinds of behaviors would you expect to see in the ideal school on the part of the other adults who work in the school, such as custodians, food service workers, clerks, security guards, and others?
- What would the school district administration be doing to support the vision of the ideal school?

Responding to questions such as these moves the process of specifying the vision very quickly. No longer is it possible to simply state, "In our ideal school, everyone cares for everyone else." Rather, it is now important to consider how "care" is actually played out and made evident to those observing what is going on in a school. Does it mean, for example, that teachers never reprimand or discipline students? Probably not, but in the caring environment of the ideal school, there may be ways of disciplining students that are markedly different from what may be seen in other schools.

In a similar vein, the interactions that occur between a principal and teachers might be typified by respect that is demonstrated through the nature of dialogue, even in cases where there is disagreement. Even during heated discussions, it is generally possible to discern that both parties respect each other by listening and communicating in a controlled fashion. By contrast, in other schools (non-ideal schools), a principal might

treat teachers as if they were adversaries who needed to be talked down to. In the ideal, caring school, open dialogue among professionals might be the rule, as evidenced by the principal talking informally with many teachers, staff members, and others throughout the course of a typical day. In a caring school, custodians might never be ordered to "clean up my office" or classroom as if they were present only to attend to the chores that teachers and others did not wish to do. Instead, they might be treated with sincere respect and dignity, as true members of the school's team of professionals. Even this final observation about what one might see in the ideal school prompts further discussion regarding how things might look in a school where professional respect was present.

The critical thing at this stage where the vision is being clarified and developed is not that every possible answer to every question listed on the previous page is answered. Rather, the critical issue is the nature of the dialogue and brainstorming that occurs with respect to issues that are often overlooked in schools because "things are too busy." The creation of a good or ideal school takes time and commitment by all who are concerned with the school.

IMPLEMENTING THE VISION

A critical part of implementing a shared vision involves matching the concept of the "ideal school" with the individual beliefs and values of those who must carry out practice in reality. Simultaneous to the actions associated with articulating the vision, conversation must take place to involve a review of mutually held values and beliefs among those who will participate and bring the ideal school to life.

Points to Ponder

- What do we believe about schools, students, teachers, administrators, and staff who would work in the ideal school?
- Why are these beliefs important?
- What would be accomplished by putting these beliefs in place?

As it was noted in Chapter 1, when individual educational platforms were described, the foundation for any action must be beliefs and values. That is as true for an entire school staff as it is for an individual educator. Dreaming about the ideal, noting a wish list of desirable practices and

behaviors, and partaking in a great deal of conversation is not likely to result in actual behavioral change or commitment if these activities are not based on a core belief system. All the descriptions in the world concerning "caring" in a school will be hollow if teachers do not respect and trust their students. Teachers and principals can appear to work in harmony but will not do so in reality if they view each other as enemies. Talking respectfully to secretaries may be a good show, but it will never change a school to any great extent if teachers demonstrate by their actions that they actually look down at staff.

Discussions about the characteristics of the ideal school are important conversations that need to take place among the leader and other members of the school community. In themselves, these sessions serve to open the lines of dialogue and enable people to learn more about other platforms. However, the discussions themselves must move forward to another level of action if they are to have an effect on the school.

In describing the individual educational platform-building process, it should be noted that the most important step involves making a personal commitment to action through a statement of an individual action plan. The same is true when an entire organization is attempting to carry out a vision of the way things "ought to be." After a review of an ideal vision, values, and desirable behaviors, the last step in the vision-development process must be a public statement and a commitment to action so that the organization lives up to its internal promises.

Often, the term used for the public declaration of an organization's vision and commitment is *mission statement.* The schema suggested in the following box may serve as a kind of blueprint to be followed in writing a mission statement for a school.

> The mission of this school is to . . .
>
> . . . IN A WAY THAT . . .
>
> . . . SO THAT . . .

What is critical to note here is that while we often see rather detailed statements of mission hanging on the walls of schools (and hotels, restaurants, fast-food drive-ins, insurance companies, bookstores, etc.), the actual mission statement is a simple and straightforward response to the question, "What do we want to do, how will we do it, and why do we do it?" In the following, some of the blanks from the earlier diagram are completed for a high school.

The mission of this school is to . . .

provide all children with a comprehensive high school educational program

. . . IN A WAY THAT . . .

encourages the pursuit of high academic goals and the development of personal interests and skills

. . . SO THAT . . .

students may be well prepared for whatever goals they have after high school graduation.

This hypothetical mission statement for an imaginary high school could be criticized because it is rather simple, or because it includes neither details about how it will be achieved nor specific goals. It is meant to serve only as an illustration of fundamental issues that may be addressed. In a real setting, greater detail would no doubt be included about the relationship of the individual school to district goals, special needs of students, or the ways in which the school is designed to serve the unique features of a particular community.

MONITORING THE VISION

Now that the vision has been developed, articulated, implemented, and incorporated into a clear mission statement for your school, the most critical aspects of a leader's job must begin. Let us assume that the staff and teachers (and community members) are satisfied that they have worked out and bought into a shared picture of an ideal or "good" school. The greatest challenge may now be to keep the vision alive and also spread the word about the vision of your school. Often, this may be referred to as the leader's role as a steward of the community. Regardless of what term is selected, it is an important duty since it is quite easy to lose sight of the ideal once a school year starts and the real begins to appear.

The educational leader, as keeper of the vision, must find ways to bring the vision back to everyone's attention throughout the school year. This might be accomplished in a variety of subtle as well as straightforward ways. For example, in some schools, signs are posted in prominent locations around the building with statements that call to mind the different elements of the agreed vision. In the main office,

hallways, the teachers' lounge, and any other high-traffic areas of a school, it may be appropriate to have simple statements or even questions such as "What have we done to make certain that X School is our 'Ideal School'?" Faculty meetings might be deliberately correlated with different elements of the vision. For example, instead of simply bringing in a guest speaker to talk with teachers about some curricular program, the presentation by the speaker might be tied directly to a specific goal or element of the overall vision for the school. In one high school, it was decided that a main part of the vision would be to ensure that any student in the school would be provided the knowledge and skills necessary to enter a four-year college after graduation. It did not mean that all students would necessarily go to college. Instead, the commitment was made by the teachers and administrators to ensure that nothing at the school would impede any student from achieving a personal goal of going on to higher education. In that case, staff meetings in the school were always devoted, at least in part, to a consideration of a single question: What are we doing to make certain that our students can go on to college? To put it mildly, in schools where the leader is committed to the vision, the vision is part of the daily conversations and practices in the school.

There is another aspect to the leader's role in monitoring the vision. In addition to making certain that everyone's commitment to the ideal does not wane, it is critical that the vision be communicated effectively and enthusiastically to others who may have an interest in what has become a direction for the school. In this regard, it is the principal's responsibility to keep those who may not have participated directly in the development, articulation, and initial implementation informed regarding the nature of what is planned in the school. Returning again to the situation described earlier where a high school envisions opportunities for all students to go on to college after graduation, there may be many new programs initiated for students to assist them in achieving this goal. New courses may be created, counseling for students may now be available, and scholarship information and many other resources designed to assist students in going on to college may now be a part of the landscape in a community. The principal needs to make this information available to families of students enrolled in the school. Parents and other community members need to become aware of what may be a very different view of what is planned in a school. The media needs to be informed of what things may be happening at a local high school. There are many people who have sincere interest in what is happening in local schools. The key is always to communicate. When change occurs, it is critical to have well-informed allies.

CREATING A VISION: RETURNING TO CARPENTER MIDDLE SCHOOL

A reality that any school leader must face when he or she takes on the challenge of a new school is that regardless of past reputations or first impressions, there is never a school that can be described as absolutely perfect or completely beyond hope. It is clear from the previous scenario that Carpenter Middle School might appear at first to be sailing along quite smoothly, without any apparent problems. Students are well behaved, teachers appear content, parents are no doubt thrilled at the fact that their children are safe and secure, and the community generally views the school with great pride—even if few non-parents have ever seen much inside the building. But to an experienced educator, there are some characteristics of the school that may cause concern. By the same token, you may encounter an assignment to take over a school that appears to be totally beyond repair. Students appear to be in charge, teachers are disengaged, and parents are frightened to let their children out of their sight to go to school each day. This school also deserves effective leadership and an opportunity for the children to learn.

If you are the principal of a school that has a negative reputation, how will you approach your teachers at the first faculty meeting of the year? Will it differ from the approach described in the opening scenario, at Carpenter Middle School? If you face the challenge of leading a low-performing school, what kinds of goals would you expect to promote as part of the vision for the next year? Will you differ from the goals you would have in a school traditionally viewed as effective? There are many ways to answer these last two questions. But one thing to keep in mind is that while conditions and appearances may change from one school to another, it may be possible to strive toward the same objectives and goals.

CHAPTER SUMMARY

In this chapter, information was provided to help you in working with the people in your school to begin the important process of defining an appropriate vision and mission to guide the collective efforts of your team throughout the immediate future. It was noted that a school (or any organization) without a deliberate vision of where it wants to go is not likely to achieve a great deal of success. But a vision can never be something that is mandated to those who work in the school; it cannot be the sole property of the formal leader. It must be something that captures the imagination and energy of everyone who will have a part in making it come true. In order to begin the process of striving

toward the attainment of a vision for an effective school, the first step must be the discovery of ways of creating a strong community as the foundation for all later effort.

POINTS FOR PRACTICE

- The first step in any effort to bring about necessary change in an organization must involve the leader articulating a vision for that organization.
- Since the vision is typically a very broad statement of a goal, the next step must be to identify a mission to guide the school or any organization in following a pattern or strategy that will give direction to the vision.
- After the mission and vision have been created, the next step must be to recognize what the enacted concepts will look like in real-life terms.
- In the development of the vision, mission statement, and strategies to achieve those goals, the leader is directive with regard to the vision, but must engage in more facilitative and guiding behaviors that enable the action plan for the mission to be created from the ground up.

REFERENCES

Barker, J. (1995). *The power of vision.* Videotape produced by the author.

Brookover, W. (1981). *Creating effective schools.* East Lansing, MI: Learning Publications.

Edmonds, R. (1979). Effective schools for the urban poor. *Educational Leadership, 37*(1), 15–24.

Lipham, J. (1981). *Effective principal, effective school.* Reston, VA: National Association of Secondary School Principals.

Lunenburg, F., & Ornstein, A. (2004). *Educational administration: Concepts and practices* (4th ed.). Toronto, ON: Wadsworth.

Foundations for Community Building

3

Damon Spencer and Maria Perez, two recently hired assistant principals, were leaving the session that they had just attended at the State Department of Education's Annual Summer Conference on "Strategies for School Improvement." As they walked toward the next session they had selected, they were joined by another participant leaving the same session they had attended. It was Phil Kawleski, their principal at Ridgmoor Middle School.

"What did you two think of that session on the importance of building community in your school?" asked Phil.

"The presenter was terrific and he certainly was a strong advocate for the notion of community building in schools," said Maria.

Damon added his thoughts to the "conference on the fly" that was taking place as the three colleagues moved from one meeting room to another. "Yes, he really was a great salesman, but I have to tell you, I've been reading a lot about this learning community stuff ever since you told us it would be part of your agenda at Ridgmoor this next year," said Damon. "But, frankly, I still don't have a really clear notion of a couple of things about all this community stuff. I want to support the idea, but almost every author I've looked at seems to talk a little bit differently about the concept."

"Can you give me some ideas about your confusion, Damon?" asked Phil.

"Mostly it's in terms of the ways in which different authors seem to be using slightly different terms to describe the same ideas."

Maria nodded in agreement. "Is there any real proof that doing all the work we'll have to do this next year to establish the school as a learning community will really help us meet our instructional goals?"

> ### Points to Ponder
>
> - As a professional educator, you have no doubt attended staff development sessions where sometimes certain "hot topics" to improve schools were described as cures. How did you react to those promises? Why?
> - What person or persons are trusted colleagues with whom you can speak openly and honestly about some of your frustrations? Why do you trust those people?
> - What is your personal reaction to the "learning community stuff" that seems so popular in today's literature regarding school improvement?

Educators often speak about how they seem to be constantly chasing fads. Over the past several years, there have been countless programs, practices, and materials that have been promoted as absolute, infallible approaches that would improve learning for students. New math, block scheduling, teacher advisor programs, and developing learning communities are all examples of innovative practice that have been introduced to schools with the implicit or even explicit promise that the adoption of the practice would truly be a miraculous cure for whatever might be ailing a school.

In this chapter, we look at the various definitions of *learning community* that have been used to guide the development of a concept that is now widely being used as a way to build a foundation for school renewal not only in the United States but in many other nations around the world. In addition, we consider why this view has become so popular among educators who now simply point to the "creation of community" as a first important step to accomplishing many other goals to support learning.

DEFINITIONS

The word *community* has long been a part of the landscape of practice in American education. As the United States grew during the 19th century, community schools offered fundamental education for all children. Until the last part of the century, formal education for most Americans consisted of developing critical skills needed throughout life to engage in everyday tasks (the "3 Rs: readin', 'ritin', and 'rithmetic"). Only two or three years of actual school attendance was the norm. After all, what type of advanced study was needed to work on a farm or in a small store in a small town? If children were near larger cities, they were often full-time workers in mills and factories by the age of 12 or 13. A little bit of education went along way in those days.

The schools of the 19th century were truly "community" schools in a number of ways. First, a school truly belonged to a local community that, in many cases at the time, served broad geographic regions. Schools served the farming community through the establishment of a school (usually the traditional one-room schoolhouse) whose students came from several miles around to learn the "3 Rs." The word *community* also was a descriptor of the curriculum development process. Each school taught what was needed by people who would spend the rest of their lives living in a certain community. "Just learn how to read a little, and write even less" could have been a motto of many schools in the country.

Another meaning of community when applied to educational practice was quite simply the notion that good schools are those in which people actually know each other. Students tended to know each other, whether they came from the same small town, lived on neighboring farms (and perhaps attend the same church

Practical Tips

For Promoting Change

As a leader, you are responsible for promoting needed change in your school to increase student learning. Often, moving a school toward the vision of a community in which all members participate in community growth is a massive change. Here are some suggestions to make that change process more manageable and effective:

- To help staff and teachers conquer a natural fear of the unknown, carefully explain potential strengths and weaknesses of adopting new programs. It is critical to be open and honest in this type of presentation; if people believe they are being "sold" with less than factual information, resistance to change will be markedly increased.
- If your teachers and staff ask, "Is this change really worth the time and effort?" do your homework! Find schools where similar change processes have taken place, get testimonials, and even try to arrange visits by your teachers to the other schools.
- For heaven's sake, avoid jargon and slogans that have so many meanings that they have no meaning at all. Teachers do not want another round of "new math," or any other programs that translate into the words "latest fad."

each week), or even lived in the same row of houses in large cities. And parents knew each other for the same reasons. Teachers tended to be products of the communities from which their students came. The key idea to remember here was that there was a social intimacy found in schools. People walked together and knew each other; children played together instead of staying in front of televisions or computer screens for hours at a time.

Finally, schools were viewed as part of community in a mutual collaboration sense. A few years ago, there was a horrible shooting of a group of Pennsylvania Amish children. As the rest of the world rushed to increase

the sensationalizing of this horrible event, television and newspaper reporters tried to get in to get the story from the mouths of parents, siblings, and others in the community. But the community formed a barrier to the outside world, preferring instead to grieve among family. And when it was time to rebuild the school where the shooting occurred, the school was built in just a few days because the community came together to share expertise and do the "right thing" to help each other through a dark time.

The 19th century (and 20th century, for that matter) is gone. With the exception of some groups like the Amish, people generally no longer live in tight emotional and physical proximity to neighbors. Huge percentages of children come from settings where the nature of parenting has changed drastically as two parents are reduced to one, and the one joins another, perhaps at multiple times during a young person's formative years. We live in a very transient society, where people are likely to move from city to city, state to state, and even nation to nation with great regularity. Adult children rarely live with parents, and for the most part grandparents are viewed as holiday dinner invitees rather than members of households. Traditional images of social intimacy in communities have changed.

Schools are huge, complex organizations. The curriculum is no longer focused on local community needs, but on worldwide requirements. And most schools are collections of individuals, not networks of pre-existing communities. In a suburban or urban high school with 3,000 students, it is quite unlikely that even a few students went through any elementary or middle school with any more than a handful of classmates at any one time. The traditional image of community has largely vanished from numerous social institutions, and schools are clearly in that group.

Points to Ponder

- In your judgment, how has the disappearance of traditional communities had an impact on schools as you have worked in them?
- If reliance on communities is an important part of improving practice in schools, how would you go about creating a sense of collaboration and unity in and around your school?

The response to the lack of community in schools and other organizations has been addressed through the work of a great number of recent organizational theorists. The individual who is perhaps most often linked

with the discussions is Peter Senge, whose book *The Fifth Discipline: The Art and Practice of the Learning Organization* (1990) may have easily been one of the most influential analyses of organizational behavior in the past quarter of a century. The principal stance taken by Senge is that all organizations, including schools, would be vastly improved if they adopted an operational philosophy of recreating themselves primarily as learning communities. He defines a learning community as

> an organization where people continually expand their capacity to create the results they truly desire, where new and expansive patterns of thinking are nurtured, where collective aspiration is set free, and where people are continually learning how to learn together. (p. 3)

Senge (1990) believes that it is in the best interests of any organization to move forward the adoption of the principles found in a learning community. But that requires fundamental change to occur in the majority of traditional organizations, one of which is the school. The changes that occur in Senge's view may be characterized as five new disciplines that must be addressed.

1. **Systems Thinking.** It is critical to begin to think of organizations not as single, isolate entities, but rather, as partners with all other organizations in its environment. Thus, it is difficult to understand the meaning of individual behaviors without learning about the norms, culture, and mores of the neighborhood in which they live. And deciphering meaning in an individual neighborhood is virtually a pointless and frustrating exercise without appreciating the impact that a city has on a particular neighborhood. But knowing about a city makes little difference without also appreciating the culture of the nation in which the city is found. Thus, a Parisian is better understood not as an individual citizen, but as someone who lives in the city of Paris. And Paris makes little sense without an appreciation of the history, geography, economy, and traditions of France.

Points to Ponder

- Can you think of an example of the importance of systems thinking with regard to education and students?

2. **Personal Mastery.** Senge (1990) defines this discipline as "continually clarifying and deepening our personal vision, of focusing our energies, of developing patience, and of seeing reality objectively" (p. 7). As an example, consider a corporation that hires a new CEO because it has been determined that a massive change—a new vision—is needed if that corporation seeks a new identity in the marketplace. Simply hiring the new CEO because she or he comes up with a good idea, or new vision, will not really have any long-term positive effect on the company if the executive does not continue to refine and polish the vision over time to adjust to new realities found in the environment.

Points to Ponder

- Identify the ways in which the concept of mastery learning may be applied in your school.

3. **Mental Models.** All people define their own reality about many learning things in life. We listen, we observe, we experience many things, and up to a point, that learning over time creates what we believe is truth and "the way things are." But true learning requires us to occasionally step back from our assumptions about reality once in a while so that we can try some new ways of thinking and acting. Mental models help us to understand and make sense out of what we see. But learners have to be willing to change their traditional ways of knowing and thinking based on new evidence that comes along. A good example of this was found five centuries ago when Christopher Columbus sailed to the west and expected to land in Asia. The prevailing view of the world at that time suggested that the body of water to the west of Portugal and Spain was the single ocean that separated Europe from Asia. No one had the knowledge that there were two continents between the West and the Far East. In organizations where the model of the learning community has been adopted, there is a distinct shift in the prevailing mental model from "some learn" to "all learn."

Points to Ponder

- What are some of the mental models that educators hold that make it difficult to move schools toward embracing the concept of schools as communities of learners?
- As a school leader, how would you move your teachers and staff to consider other perspectives than the mental models that have been followed in the past?

4. **Building Shared Vision**. Developing an organization that is committed is a process that takes much more than a single leader announcing, for example, that "I have changed the mental models" here so that "we may now engage in systems thinking" and "develop mastery." Building shared vision is not something that can be accomplished overnight. It takes work and a solid commitment by the leader, as noted in Chapter 1, to believe that more involvement by many in the organization will lead to a more effective organization.

Points to Ponder

- To what extent do you believe your school now has developed a shared vision to drive its efforts to improve in the future?
- How broadly has support for the school vision been developed so that there is a sense of ownership by everyone in the school?

5. **Team Learning.** In Senge's view, this may be the single most critical of the disciplines; it is the foundation of all action in an organization, where many are brought together to focus on the development of a shared vision that can lead the organization to greater effectiveness. According to Senge (1990), "Team learning is vital because teams, not individuals, are the fundamental learning unit in modern organizations . . . unless teams learn, the organization cannot learn" (p. 10).

Points to Ponder

- To what extent have teams of teachers, administrators, staff, and others been engaged in planning school improvement activities for your school? What have these teams actually done?
- In what ways have teams served as the foundation of learning in your current school, or in any school in which you have worked in the past?

Senge's work has had a very powerful impact on the thinking and actions of educational leaders who have tried, often in vain, to return to the traditional sense of community that was such a forceful tradition in schools of the past. The Victorian Ministry of Education (1995) in Australia adopted the concept of "schools as learning communities" as a statewide unifying theme to guide efforts at school improvement. In a concept paper, the

following values, important when adopting the learning community model, were identified (Victoria Ministry of Education, 1995, p. 3):

- Promote the development of a culture of continuous improvement
- Increase opportunities for increased innovation and creativity
- Enhance skills and understandings throughout the school
- Improve broad-based commitment and energy
- Improve the capacity to change environments and circumstances
- Develop greater responsiveness to the external environment
- Improve training and development programs for all members of the community
- Promote more effective school and community partnerships
- Improve the quality of student outcomes

Several values associated with thinking of schools as learning communities have been identified. But it still does little to answer the original question of definition. We know that community thinking was a regular and ordinary part of American life in the 19th century and into the early part of the 20th century. We know that schools were part of communities and that communities were focused on schools. Parents knew teachers, and teachers knew families. Schools worked because people in local areas banded together to make things happen, to support schools, to teach their children values at home, and to reinforce teachers' efforts in classrooms.

We also know that as American society grew from small-town and rural lifestyles to urban environments, a virtually predictable outcome was that the natural sense of community would be lost to a large degree. Even in rural America, it became increasingly difficult to maintain the same sense of small community as one-room schoolhouses disappeared, curriculum became more inclusive of knowledge outside the "3 Rs," and parents began to stay away from involvement in their local schools in greater numbers.

But the power of small and intimate learning opportunity continues to be recognized as a powerful and positive feature of good schools. In 1996, the National Association of Secondary School Principals, with support from the Carnegie Foundation, issued a report titled *Breaking Ranks: Changing the American High School*. This report proposed many ways to promote changes in the quality of secondary school learning experiences through modifications of the ways "in which things have always been done" (p. 3). One of the most controversial recommendations concerning improvement in high schools was the view by a committee composed of experienced high school teachers, administrators, and central office administrators that high schools should enroll no more

than 600 students in each school. The recommendation was soundly criticized by "realistic" taxpayer groups, teacher associations, and school boards and superintendents as having proposed a highly impractical solution to high school problems; the committee remained steadfast. The rationale was quite simple. One of the greatest challenges facing American high school leaders is based in the huge size of a great many existing schools. Quite simply, students become lost in organizations that often have more than 3,000 students, 200 faculty members, numerous classified staff members, and large administrative bodies.

Whether it is practical to greatly reduce the enrollments of most high schools across the United States or not is really not the point of this last example. A great number of the learning and behavioral difficulties is likely caused by the fact that the size of a large percentage of schools creates conditions where many students feel disconnected to what is going on around them. There is a feeling of anonymity among students who feel lost in a crowd or separated from any sense that anyone really cares about them as individuals. One can hardly expect that school districts across the nation would return to the days of one-room schoolhouses just to make the learning environment seem more "personalized." Yet the effort has been made for many years to find ways to make schools more focused on individual student needs, a perspective that is hard to do when good schools are often viewed as efficient schools, that is, ones in which lower amounts of money are spent on each student while test scores and other indicators of large group effectiveness are maintained or increased. In an effort to maintain efficiency in schools while also creating more of a sense of community, some alternative strategies have been tried to personalize schools, particularly at the secondary level. For example, the Chicago Public Schools (2008) has launched a deliberate effort to focus schools on individual student needs by creating several experimental "small high schools" across the city. These have typically been limited to no more than 500 students who are admitted through a lottery process. Other schools have addressed massive size and student alienation through creating smaller "schools within the school." In these cases, smaller schools are created with different types of programs offered to attract students in smaller numbers. Once again, it is not unusual for the "sub schools" to be limited to enrollments well below those of traditional high schools in a district.

OPERATIONALIZING COMMUNITY BEYOND STRUCTURE

Efforts to create smaller groupings of students as a way to increase a sense of community have taught us that while these attempts have been created

with great intentions, simply mandating small size through alternative structures will not automatically return schools to the sense of intimacy and safety enjoyed one hundred years ago. The literature of recent years has been clear in noting that there are many other features of communities that are even more important than simply reducing numbers. Richard DuFour (2008) has become widely associated with the development of learning communities in schools. He noted that there are a number of distinct features to be found in a school devoted to the notion that learning occurs most effectively when a communal focus is developed to guide student development.

Learning Communities Are Based on the Belief That the Primary Goal of Schools Is to Ensure That Students Learn

According to DuFour (2008, p. 8), "The professional learning community model flows from the assumption that the core mission of formal education is not simply that students are taught but to ensure that they learn. This simple shift—from a focus on teaching to a focus on learning—has profound implications for schools."

This statement represents both a philosophical or platform-based shift and also a very revisiting of current perspectives on school improvement. Increasingly, schools are viewed as effective or not based on one simple (but often difficult to answer) question: Are students learning? Too often, schools were described as good or bad based on their physical facilities, the amount of money provided by local citizens to run the schools, the number of cutting-edge and innovative programs available to students, and how well teachers teach. All of these issues are, of course, important to some extent in assessing the quality of a school. But the issue that must always remain constant and high on the list of priorities is whether or not students are in fact learning.

Many schools and school districts proclaim their commitment to the central responsibility of focusing on the students. It is a popular statement to note, for example, that "The XYZ Schools are truly dedicated to the belief that 'All Children Can Learn.'" This statement is a wonderful thing to say, and it may even make taxpayers believe that their local school is doing great things. But saying and doing are two different things. In a school where teachers, administrators, and staff members work along with parents and other community members, it is possible to begin to understand what a school dedicated to keeping student learning as a central mission would look like.

DuFour (2008) suggested three critical questions that need to be considered by all who work in a school dedicated to creating a learning community to serve students:

- What do we want each student to learn?
- How will we know when each student has learned it?
- How will we respond (as a community) when a student experiences difficulty in learning?

Points to Ponder

- How would you respond to questions such as these as they might relate to your current school?
- What additional questions do you believe should be asked if a school is interested in creating learning communities?

In the school dedicated to the principles of learning as a community, these questions are more than simply general reflections on what can be done in a school year at a given school. Instead, they represent a kind of call to arms for everyone to reflect on the critical issue of what actually happened to students, and what the school as a community dedicated to serving the needs of all students will do collectively to actually make sure that students learn. Slogans are easy to create; action plans take a lot more work to enact. It takes colleagues working together to engage in the process of deciding what things are important and essential for all students to learn. Then ways of assessing whether or not learning must be constructed, based on the differences among individual students. Finally, colleagues focusing on student learning need to identify appropriate strategies that can be used by the students who still fall through the cracks.

A Culture of Collaboration Must Be Constructed

The importance of establishing an appropriate climate or culture to promote and support ongoing collaboration among all who work in a school will be discussed further in the next chapter. But for now, it is important to identify the issue of a collaborative culture being an important aspect of any school interested in working as a community. To create a true community for learning in a school, there must be ongoing dialogue and cooperation among all the members of the teaching, paraprofessional, classified, and administrative staff within a school. It must be part of a school's mode of operating to the extent that all matters affecting the whole school must be considered by all who have a stake in the school, and that group is always the teachers, staff, administrators, paraprofessionals, and classified staff. One might also lobby for the inclusion of

students, parents, and community members to be part of the community of decision makers to be consulted when the overall welfare of a school is considered. This culture of collaboration must be safeguarded as a central part of "the way we do things around here."

Disagreements are bound to occur even in the strongest and most tightly knit communities. In fact, one might argue that one characteristic of a true learning community is that it must be an organization which does not engage in groupthink as a matter of fact. Conflict, argumentation, and open discussion are realities that are always likely to occur in any dynamic organization where the focus of the collaborative efforts is always directed outwardly, toward goals and objectives beyond the individual needs of individual group members. The critical feature in a culture of collaboration is the reliance on a norm of transparency and open discussion of matters of policy and practice. Remember that collaboration is not an end in itself. Rather, it is a vehicle to move the total school to levels of performance well beyond what might be found in a setting where individuals remain committed to personal agendas.

Points to Ponder

- To what extent do you believe that a culture of collaboration exists in your present school?
- If a commitment to collaborative work does exist, how was that culture created? If not, what is preventing a collaborative culture from being developed?

It needs to be acknowledged that this step in the creation of a learning community might be the most difficult one to achieve. In Chapter 4, some of the traditional factors that have existed in schools to block more open dialogue among interested parties are considered. If these factors cannot be overcome, it will be quite difficult to move forward with your vision of a true learning community.

The Community Must Be Focused on Results

DuFour makes it quite clear that school-based communities of learners are never to be thought of in slogan-like terms. Simply calling a school staff a learning community will not make a school better. In DuFour's (2008) view, schools are more effective when the community focuses on a single identified goal, namely to increase the quality of learning by students. As DuFour has noted,

Professional learning communities judge their effectiveness on the basis of results. Working together to improve student achievement becomes part of the routine work of everyone in the school. (p. 10)

This persistent emphasis on the importance of working toward a clear and measurable goal, such as the improvement of the student shown through the results found in student achievement, reporting adds an important dimension to what we considered in Chapter 2, namely the importance of a clear vision to guide the work of the school. While it is true that visioning involves imagining and considering the very best possible scenario, it is critical that the vision-building process move quickly toward a more concrete stage seen in this emphasis on defining clear outcomes. Joel Barker (1995), a futurist, has noted that a "vision without action is only dream; action without vision is simply passing the time away; but action with vision can change the world." Schools can ill-afford trying to function as dream worlds. So the need to maintain a clear commitment to the improvement of learning by students is a critical part of the discussion of those who will serve as partners in the collaborative discussions and actions of the learning community.

Points to Ponder

- To what extent do the teachers and others direct their conversations, planning, and daily actions toward the improvement of student achievement and learning?
- What experience does your school already have with moving toward school improvement based on the creation of collaboration within the community?

RETURNING TO THE ADMINISTRATIVE TEAM AT RIDGMOOR MIDDLE SCHOOL

The two assistant principals and the principal leaving an inservice program and discussing the message of the keynote speaker is not an unusual scenario from the world of education. Teachers, administrators, parents, staff members, and students often engage in critiques of one sort of another of all efforts to ensure more effective practice in schools. And there is hardly an end in sight to the programs, projects, and materials that are trumpeted as "surefire" ways to make schools more effective and increase student learning. The result has been understanding skepticism by experienced educators.

The concept of creating learning communities in schools, however, is far from a new "canned" inservice program, series of books, or consultant interventions. Creating the image of a school functioning as a true community is a much more effective proposal if for no other reason, there is simply not a single model to be bought or implemented. Creating a sense of community requires little more than a fundamental belief that everyone in a school has something to contribute to the quality of life in a school. In that regard, the assistant principals in the scenario should feel confident that they are working with an experienced principal who sees the opportunities, not the obstacles, for working toward community as a school goal.

CHAPTER SUMMARY

In this chapter, the concept of what community means was discussed. It began with a consideration of the definition of this term, and also a review of why making modern schools feel more like real communities has evolved over the years. In short, schools have often become so large and impersonal that ways of reducing the sense of isolation among students have become critical goals of those who would work toward reform of modern educational practices.

Work by Peter Senge was noted as influential in promoting much of the recent dialogue in schools regarding the importance of systemic thinking as a first step in promoting greater sense of shared purpose and vision that is needed to support any effort to change practice. Schools must strive for greater clarity with regard to focusing their efforts on the needs of students. This clarity must begin with a commitment of all adults who work in schools to join with colleagues to create a collaborative environment where students actually do come first.

The chapter concludes with a review of the steps that need to be followed in creating the conditions that need to be considered by school leaders who wish to create learning communities in their schools. These steps were recommended by Richard DuFour, a strong proponent of schools dedicating themselves to the concept of community. While these steps are designed to serve as a kind of recipe for the creation of community, it is important to note that there is an essential quality of each item with the most critical one being the first on DuFour's list. Simply stated, schools wishing to re-form themselves according to the learning community must begin their efforts through a sincere commitment to the importance of students and their learning as the ultimate and most critical goal for all who work in and around schools.

POINTS FOR PRACTICE

- There has long been a tradition in American education to provide schooling that would enhance the sense of community in schools.
- Much of current efforts to increase parent and community involvement in schools is derived from the traditional values of American public education.
- Current proponents of communities in school now typically refer to these activities as professional learning communities and emphasize the strength that such organizational structures provide to the improvement of schooling for students.
- It is worth the effort to forge a sense of community in all schools today, regardless of size.

REFERENCES

Barker, J. (1995). *The power of vision*. Videotape produced by the author.

Chicago Public Schools. (2008). *Directory of new small high schools*. Chicago, IL: Chicago Public Schools, Office of Principal Preparation and Development.

DuFour, R. (2008). *Revisiting professional learning communities at work: New insights for improving schools*. Indianapolis, IN: Solution Tree.

National Association of Secondary School Principals. (1996). *Breaking ranks: Changing an American institution*. Reston, VA: Author.

Senge, P. (1990). *The fifth discipline: The art and practice of the learning organization*. New York: Currency Doubleday.

Victoria Ministry of Education. (1995). *Learning communities: A white paper of the Ministry of Education*. Melbourne, Victoria, Australia: Author.

Focusing on Culture Is More Than Good Manners

4

When Marsha Fields accepted the position as the new principal of Manchester Middle School, she knew she would be in for a very challenging experience. The school had gone through five different principals in seven years. By whatever measures of school quality imagined, the school was in terrible shape. Attendance rates each day were horrible; on some days, fewer than 75 percent of the students enrolled in the school reported to classes. A good percentage of the absent students were determined to be truant. And when efforts were made to tighten up attendance each year, significant numbers of students transferred to other schools in the district. This caused the school staff to be unable to provide accurate accounts of the actual number of students who were enrolled at Manchester Middle School from week to week.

Perhaps not surprisingly, the abysmal attendance rates at the school were accompanied by student achievement test scores that were among the lowest in the region. In terms of No Child Left Behind standards, the school had been far from demonstrating Adequate Yearly Progress (AYP) for several years. Technically, parents of Manchester students could have moved their children to other district schools two years ago, but few exercised that option because moving their children would have meant significant changes in the lifestyles of many families who lived very close to the school.

The second day after the staff arrived following summer vacation, Marsha called an emergency faculty meeting to enable the teachers to express their views concerning the reasons for the unfortunate conditions that were now making Manchester Middle School appear to be the worst school in the district and among the worst middle schools in the entire state. Admittedly, this would be a risky thing to do for a new principal who did not yet know most of her faculty. More important, the faculty and staff did not know her. But she would start the session by admitting the obvious: Manchester was a mess, some things had to start changing, and change had to begin immediately.

The first few minutes of the meeting followed the typical pattern of most beginning-of-the-year faculty meetings. Marsha introduced herself and other new staff members and shared a few things about how happy she was to begin her career as a principal with a good group of colleagues. The reaction by the assembled staff was polite but reserved. There was obvious body language indicating resentment by several teachers who were told to report for an emergency meeting before they had really gotten into the mood for starting a new school year.

After an awkward beginning of the meeting, Marsha got to her main purpose straight away. Time was working against the school. With a new superintendent and a recent election that meant the departure of a majority of board members who protected Manchester in the past, there would have to be some major change or the school would surely face either closing or at least reconstitution at the end of this school year. Despite this very hard reality, Marsha knew that many teachers in her school were probably as frustrated as anyone with what was happening, so she was careful in stating that she was not there to find fault, but rather to seek solutions. She quickly opened the floor so that teachers could share their own ideas of what had been happening.

Marsha was really amazed with how quickly and forcefully a great number of teachers started to share their perceptions of what the problems were at Manchester Middle School. The first few people made it quite clear that their new principal was going to be surprised at what was really going on at the school. According to their assessments, there was little that anyone was going to be able to do to make much of a difference in the quality of the school. Three or four teachers basically said that Marsha was likely to be another short-timer in the building, like so many of her recent predecessors. When Marsha asked for a clarification of what almost sounded like a threat from one of the teachers, she was told, "No offense, but you will soon find out that the reason that we have problems here is that there are so many problems 'out here,'" as he pointed to a window where one could see several public housing projects clustered near the school. The stories, with specific examples, continued for almost another hour. Again and again, Marsha heard stories about parents who seemed to care nothing about the progress that their children were making in school, low attendance at any parent conferences, and generally negative attitudes about schools and the value of education. Students came to school with an attitude. The overall impression that one got from the statements made by teachers and several classified staff members was that the workers in the school had taken on a collective view of the school being filled with children who simply did not want to learn, mostly because of the attitudes that had been shown by parents and community members. As one experienced teacher said with a remark that closed a very unhappy beginning-of-a-new-year faculty meeting, "You know, teachers are all supposed to say that they believe that all children can learn. But here, at Manchester, we have given up and generally concluded that many kids do not want to learn."

Marsha went home after that session with feelings of frustration, anger, and a sense that she was facing an impossible task. She knew that what she had to do would not be solved with stricter attention to attendance, more afterschool workshops to help teachers work on basic skill development, or pep rallies in the gym to make the students happy to be Manchester Mountaineers. She remembered reading about schools where there was a sense that nothing could be done to teach students. It suddenly hit Marsha that she was now the principal of such a school.

The case of Manchester Middle School is, unfortunately, not a unique or even exaggerated example of a problem facing many educational leaders across the United States, or even around the world. Some schools give evidence of what some writers refer to as a "toxic culture," or an "anti-learning attitude." And professional educators seem to be at the center of that culture and attitude.

Points to Ponder

- What is your assessment of the principal's decision to call for a faculty meeting before she even had time to meet each person individually?
- How might you have approached the issues that were the basis for the faculty meeting?
- If you agree with the teachers' views that students were unsuccessful because parents were not engaged in the school's work, what would your next steps be?

ON CLIMATE AND CULTURE

Researchers and others have long been interested in finding ways to compare and contrast schools and organizations based on characteristics or qualities that might be measured or evaluated objectively. As a result, the tendency today of assuming the difference between "good" schools and "bad" schools is based largely on such quantifiable measures as average test scores, numbers of students who drop out, numbers of discipline referrals, and other similar countable features. Legislators and the lay public in general tend to be drawn toward very concrete data that "clearly" indicates that any school that has not met or surpassed high enough passing rates on a statewide achievement examination is inferior to other schools which have met the standards desired by local policies or even federal demands.

However, most experienced educators know that there is much more to a good school or bad school than the average scores achieved by third- or fifth-grade boys (or girls), or minority-group students (or nonminority-group students) on a statewide test on reading skills. In addition, the current emphasis on defining poor performance in a school almost exclusively on the quality of teaching or leadership present in a school at a given moment places too much emphasis on activity that is, by its nature, a short-lived event in the life of a learner. What often results in this type of thinking is that third-grade teachers blame second-grade teachers because a high percentage of third graders did not pass the state exam.

And of course, second-grade teachers note that if the Kindergarten or first-grade teachers had done their jobs effectively, the students in second grade would have succeeded!

While there is no doubt that the quality of teaching and leadership in a school contributes greatly to learning, such activity cannot be either praised or blamed for all the measurable outcomes of a school. Educators are often quick to point out that there is little support for their efforts at home and that parents "do not seem to care" about what is happening with their children. And "if we didn't have all these kids who come from housing projects," scores on tests would be much higher. The circle of blame continues to serve as an explanation for what goes on in many schools.

To some extent, these observations have validity, but none of the things that are part of the reality of public schools is a full explanation of what goes on in terms of student learning. If the socioeconomic status of children, involvement by parents, or quality of prior instruction received by children were sufficient explanations for why children do not learn, then why are there many examples of children succeeding even when they face horrible living conditions, no parent involvement in their lives, and on occasion, poor teachers at one grade level or another?

The answer, at least in part, may be based on a highly difficult concept to get a handle on by both theorists and practitioners. This "fact of organizational life" cannot be seen on the outside of the school when one drives by in a car. It cannot be smelled or heard when one walks into the school, and it is not found displayed in any chart showing data comparing one school to another on the front page of a local newspaper. Yet this fact of life is a powerful characteristic that deserves attention by any leader who would like a school to be known as effective. In popular terms, this intangible quality of a school is referred to as its culture.

To make a clear comparison in the suggestion that culture of a school makes a difference, consider the following: Most educators have been in

many schools during their careers, as teachers, visitors, meeting atten-
dees, and perhaps as parents of school-aged children. In some cases, the
person walking in can almost immediately recognize that the school is in
trouble. From the moment that one walks in to the principal's office (and
no one pays attention to his or her presence), walks down a hall where all
classroom doors are closed, hears teachers raising their voices in angry
tones, sees litter in stairwells or in main corridors, and notices many other
small features, the visitor feels unwelcome or uncomfortable. Yet a glance
at the school's performance levels on achievement testing suggests that it
is a "good" school.

In other cases, a visitor might feel quite differently about his or her
experience. Smiles greet the visitor from the time he or she enters the
building. At the principal's office, someone behind the counter says "good
morning." During a walk down the hall (clearly well maintained and free
of litter), the visitor hears the sounds of teaching spilling out into the hall.
Passing teachers and students say hello to the visitor, artwork by children
decorates the halls, and there is a general sense of order, but not obvious
control, present in the school.

In the first case, the visitor might use words like "cold" or "unfriendly"
to describe the feel of the school, and he or she might seek as quick an exit
as possible. In the second case, there is a sense of warmth and purpose
that makes the visitor want to spend more time in the school. The differ-
ent feelings by the visitors are what we believe we can call the culture of
the school.

Points to Ponder

- What do you believe would be the type of impressions that a first-time visitor
 would have after coming to your school? On what features of your school are
 you basing your answer?
- If you believe that visitors would have a positive impression, how would you build
 on that? If impressions would be negative, what would you do to change that?
- Would first-time visitors to your school want to send their child to your school?
 Why or why not?
- What can a principal do to either build on the good impressions or change the
 bad ones?

DEVELOPMENT OF CULTURE AND CLIMATE RESEARCH

Sociologists and social psychologists have tried to answer a very important
question for many years. Simply put, people who look at organizations are

focused on "What is going on here?" For many years, this question was answered through the creation of numerous research-based theoretical models such as the Social Systems model developed by Jacob Getzels and Egon Guba (1957) at the University of Chicago. This model proposed a theory that suggested that "what is going on" in schools, banks, universities, hospitals, and all other organizations in society must be understood in terms of an ongoing dynamic interaction between the defined structure of an organization and the people who work or live in that organization.

Another example of a researcher who tried to develop an understanding of what's going on in organizations was Jerald Hage (1965), a sociologist at the University of Wisconsin–Madison who developed what he referred to as an Axiomatic Theory of Organizations. While the suggestion that his conceptualization was indeed so clear as to be axiomatic may be disputed, Hage's work was highly influential in terms of its ability to understand that in any complex organization, two elements must be understood as the basis for understanding the nature of that organization. One element is its structure, including such characteristics as centralization (how diverse is involvement in decision making), complexity (the number and variety of occupational roles and specializations in the organization), formalization (the proportion of jobs that are narrowly defined and codified), and stratification (differences in income and prestige found in an organization). The second element of his theoretical perspective includes the outcomes of an organization. He includes four measures of what an organization does: production (the number of things that are produced in an organization), efficiency (the cost per unit to produce things), job satisfaction (the extent to which employees are likely to not leave an organization), and adaptiveness (the extent to which an organization engages in innovative practice). The purpose of these elements was not to evaluate an organization, but rather to simply provide ways of classifying and differentiating different types of organizations. Regardless of demonstrated characteristics within the two elements, Hage's model makes no effort to classify some organizations as good while others are bad. The model is also useful in suggesting that, like a mathematical equation, if certain structural characteristics of an organization are modified, outcomes are also likely to be changed. For example, in a case where a change is made to restrict the number of organizational stakeholders from participating in making important decisions related to the organization, it will increase the efficiency of an organization (it takes a lot longer to make decisions if everyone is asked for an opinion). On the other hand, decreasing opportunities for participation in decision making may have an undesirable affect by decreasing the overall level of job satisfaction in the same organization.

The descriptions that we have just reviewed briefly reflect researchers' perceptions of formal, or structural, characteristics of organizations. While these are important to the development of further theory related to organizational behavior, they do not really tell the full story of what goes on in schools or other types of institutions with which leaders must interact. School personnel know that there are certain aspects of school life that simply do not fit with structure or assumed outcomes.

Some authors such as Andrew Halpin and Donald Croft (1963), Matthew Miles (1965), and Lee Bolman and Terrance Deal (1991) have described organizations in terms less measurable, but perhaps more consistent with common definitions used by practitioners.

Halpin is generally viewed as the first researcher who tried to explain differences between schools in terms more frequently used by those who work in schools each day. He noted that there are six types of organizational climates: open, autonomous, controlled, familiar, paternal, and closed, with an open climate being most positive, while a closed climate would be the least desirable environment in which schooling might take place. Each of these climate types was defined according to the extent to which each possessed a high, medium, or low amount of eight behavioral patterns: disengagement, hindrance, esprit, intimacy, aloofness, production emphasis, thrust, and consideration. Without going into great detail, consider the brief comparisons of the two most completely different climate types—open versus closed—noted in Table 4.1.

Table 4.1 Comparison of Open Versus Closed Organizational Climates According to Halpin's Theory of Organizational Climate

Open		Closed
(low)	Disengagement	(high)
(low)	Hindrance	(high)
(high)	Esprit	(low)
(medium)	Intimacy	(medium)
(low)	Aloofness	(high)
(low)	Production emphasis	(high)
(high)	Thrust	(low)
(high)	Consideration	(low)

Miles (1965) identified 10 dimensions that indicate the relative health of an organization:

1. Goal focus (extent to which people in an organization understand and accept organizational goals)

2. Communication adequacy (facility of communication that takes place within an organization)

3. Optimal power equalization (balance among organizational members that makes it difficult for one internal group to grab absolute power and control)

4. Human resource utilization (effective use of organizational personnel)

5. Cohesiveness (the extent to which members like their organizations and want to retain membership in them)

6. Morale (feelings of well-being and satisfaction expressed by organizational members)

7. Innovativeness (the willingness to try new programs and procedures to enable an organization to develop and grow in the future)

8. Autonomy (an organization's recognition of forces that must be heard in the environment, but the ability to avoid the temptation of acquiescing to those forces completely)

9. Adaptation (the ability of an organization to anticipate change and engage in behaviors that will enable it to address future demands)

10. Problem-solving adequacy (the maintenance of strategies for sensing problems, and also developing strategies to deal with crises when necessary)

In short, when an organization engages in each of these 10 positive behaviors, it can be termed a healthy organization. When one or more characteristic is reduced or disappears, the organization becomes increasingly unhealthy.

Finally, Bolman and Deal (1991) advanced a more artistic approach to organizational analysis through a conceptualization of four alternative interpretations of organizational structures and processes that they refer to as frames. The four frames developed by Bolman and Deal (2002) are defined as follows:

Bolman and Deal's Frames

1. **Structural frame.** This emphasizes the understanding of organizations through an appreciation of formal roles and relationships. If you want to understand a school, for example, look at job descriptions and the organizational chart.

2. **Human resource frame.** Here, the emphasis is on the people who inhabit the organization. If you want to understand a school, look at the ways in which people who work in and around that organization behave.

3. **Political frame.** The emphasis is on developing an understanding of the ways in which competing groups seek control over power and resources. If you want to understand a school, look at who gets what in terms of resources.

4. **Symbolic frame.** This emphasizes reviewing the cultural histories, rituals, and heroes found in an organization. If you want to understand a school, look at the people who are most revered, along with the important traditions.

These and many similar theoretical descriptions of the informal structure of organizations have been used for many years. However, the subtle "feel" of complex organizations like schools will always be a challenge to those who wish to understand why things happen as they do.

Points to Ponder

- How would you describe your current school by using the terms in the organizational climate theory of Halpin? The organizational health perspective of Miles? The four frames of Bolman and Deal?
- Which of the three theories of informal organizational characteristics appeals the most to you? Why? How would you use these insights in a presentation to teachers in your school?

PUTTING THE THEORY INTO PRACTICE

As noted above, the research community coming from a variety of disciplines such as sociology, psychology, business, and education has contributed significantly to our ability to describe and categorize different types of organizations, from both a formal and informal perspective. However, in the cases of Getzels, Hage, Halpin, Miles, and others cited,

there has not been an effort to juxtapose the findings of research with practical strategies to be used in school settings to achieve any specific goals. As researchers, that was never the intent of their work. However, leaders of schools with a vision of creating more effective and dynamic programs for learners through the creation of a sense of community may borrow from the thinkers as they serve as doers in real-world schools each day. Efforts to create organizational patterns of behavior that will lead to a sense of common focus and action on goals start with a review of concepts such as the dynamic structure of organizations, more open climate, and healthy schools.

All schools start from different beginning points in terms of their pursuit of more developed and effective community spirit. We propose that it is possible to create organizations that embody the spirit of a community based on the extent to which fundamental issues are addressed. These two issues are the sense of togetherness among the workers in the school (i.e., the sense of "we" that exists) and the collective work behavior in the school (i.e., how much do the workers think of "our" behavior in achieving "our" goals).

The sense of togetherness is a way of describing the extent to which there is an existing sense in a school that people care about the welfare of each other. In many schools, there is truly a strong sense of teachers, administrators, staff, students, and parents developing close bonds. In many ways, they appear to be very cohesive groups. Outsiders look at the people in a certain school as if they were one big happy family. There is often a great deal of team spirit, where the teachers get together to socialize after work (often to give thanks on Fridays), birthdays are celebrated, sporting events are held where the teachers from one area of a school compete in volleyball games and similar activities with teachers in another part of the same school, secretaries and other classified staff are given gifts at holidays, and many other similar activities are seen that signify that the people in a school truly are happy to be sharing the same work address each day.

The sense of common goal focus or common purposing is demonstrated in schools by teachers working toward some sort of widely accepted set of expectations proposed by the school district, the state department of education, the parents in a community, or the administration of their individual school.

In a school with a high degree of group commitment to organizational goals, one would expect to see teachers working toward very specific and well-defined goals such as achieving high scores on high-stakes tests and other measures of accountability. It might also include teachers working toward some kind of overall goal such as the attainment of some type of statewide or even national award or recognition.

The two dimensions consisting of people working together harmoniously and people working toward common goals and objectives can be understood in terms of a model that will be described in terms of Four Cs, which connote four different stages of development (or perhaps, nondevelopment) of a school into a true functioning community. These stages, conditions, or cultures in a school are Cocoons, Congeniality, Competitiveness, and ultimately, Collegiality.

Cocoons

The teachers and other staff members work independently in their pursuit of either individual goals or goals established for the school from outside. A school where the prevailing model is one of teachers working in isolation can be compared to the way in which silk worms spend the earliest stages of their lives developing completely apart from other elements of nature. They live life separated from any contact with other silk worms. As the silk worms emerge from their cocoons, they engage in the complex yet lonely task of spinning a small portion of a cloth that cannot be seen from the level of the workers. There is little doubt that the efforts of each worker is amazing and of the highest quality. But the sad thing about the creation of a silk garment is that those who contribute most to its creation will never appreciate the contributions of their work to the total product. In a school where the behavior of teachers is best defined through the analogy with cocoons, individual instruction goes on in individual classrooms led by individual (and isolated) teachers. Like the silk worms, those doing the job never really see the sum of their combined efforts. Students move along from one independent worker to another. They may learn a great deal from each teacher, but there is never an effort to bring learning together into a discernible total object. In terms of the two dimensions noted as the basis for this model, schools where teaching is best described through cocoons is low in terms of togetherness among staff, and it is also absent from collective focus on schoolwide goals and objects. Students learn as long as each individual teacher does his or her job in his or her classroom with his or her students.

Congeniality

The second C stands for Congeniality. In this quadrant of the model, the emphasis is exclusively on the school staff getting along as workers in the same enterprise. It might also be referred to as the One Big Happy Family approach to community in a school. Schools where there is a strong commitment to congeniality are happy places. It is clear that

teachers, administrators, and staff members get along and enjoy each other's company. The faculty lounges are generally filled with people telling jokes, sharing personal events, and engaging with each other as individuals. People meet together socially on weekends and during holiday breaks. In general, the sense of camaraderie in these types of schools makes them feel very warm and welcome to any outsider. And the best part is that students typically respond positively to the type of environment generated by teachers who seem to know each other and care about each other. However, the downside of a school where congeniality is the driving force among all is that, in many cases, the actual work toward mutual goals may be put on a back burner. Indeed, it is enjoyable to work in the climate of congeniality, but it may not be a great surprise that important things (like test scores and achievement by students) may fall through the cracks.

Competitiveness

The third C is Competitiveness. Contrary to the open spirit among those who interact in a Congenial environment, those who work in a climate of Competitiveness often avoid any direct contact with colleagues, except when that colleague is beneficial to an individual's pursuit of a personal set of goals and objectives. In some ways, there are apparent overlaps between the Competition quadrant and what is observed in the Cocoons. There is a distinct lack of much sense that people are all on the same page. However, the great difference is found in the fact that in Cocoons, teachers and others deliberately do not get involved in ways that contribute to the overall feel of the school. They stay in their classrooms, keep their doors shut, do their own thing, and above all, select deliberate paths that indicate no interest in any involvement with schoolwide concerns. By contrast, in Competitive cultures, people may choose to stay disengaged from others, but they do so for the purpose of devoting all of their time and energy to work that contributes to their personal goals and objectives. In the Competitive school, teachers do not share their strategies for achieving success in their classrooms. In fact, the attitude of most is that they are responsible for their students and their students alone. When students in individual classes achieve success on tests or other awards, the tendency in the Competitive school is one of assuming that the success of the individual child is really the result of the talent of his or her teacher and not through the efforts of a whole educational team. The talk of using merit pay to reward teachers based on test scores achieved by students makes it increasingly appealing for teachers to work toward student achievement in isolation from collaborative work efforts with other staff

members. In a conversation with one teacher who was opposed to the use of student achievement as the primary base for individual teacher merit rewards, it was noted that schools face complex issues when trying to work with students. There is already too much emphasis on the power of individual teachers bringing about either student success or failure. The criticism from the teacher was that there are already too many ways in which teachers are being isolated from collaborative work with colleagues. Having said this, it must be noted that competition among teachers still exists in a large number of schools across the United States and elsewhere.

Collegiality

At the top of the Four Cs Model to bring about schools dedicated to collective success of all students is the quadrant referred to as Collegiality. Educators often use the term *colleagues* to refer to other teachers and administrators in their schools. Often, however, this term is used to describe little more than individuals who work in the same building as everyone else. True collegial behavior occurs only in settings where there are genuine feelings of respect and camaraderie among workers. People not only like each other, but they are on the same page regarding professional issues. These are among the best features of a Congenial organization. However, simply working with and enjoying others who work in the same place is not enough to make an organization effective. There must be a strong commitment to the work itself. In a Collegial environment, people work together to achieve important organizational goals. Contrary to the Competitive setting, people do not hide in their classrooms to work with "their" students. They take pride in the work and accomplishments of everyone with whom they work because what goes on in a school is good for all students. Teachers and others who work in schools classified as Collegial would probably not disagree with merit pay if pay were distributed equally among all the teachers in a particular school where student achievement was high. Collegial environments lend themselves easily to the adoption of practices consistent with a view of schools as learning communities. Figure 4.1 depicts the relationship of the four quadrants in the Four Cs Model.

The leader who is striving to create an environment conducive to the creation of a learning community needs to engage in activity that will steadily move his staff toward the Collegiality environment. If there is a sense that the school is in a Cocoon state, it will be important to seek greater engagement from all staff. Committees and work groups to examine critical instructional issues can be created to afford both the opportunity and the need for teachers and staff to "come out of the shadows" and

Figure 4.1 The Four Cs Model

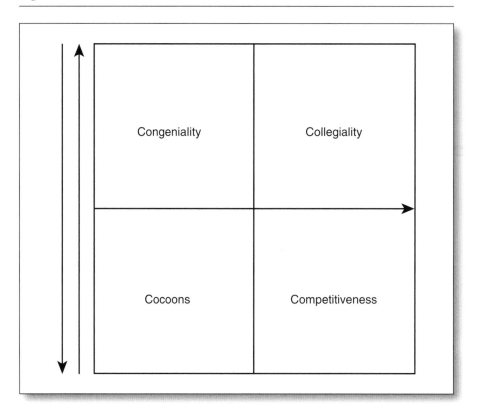

work with others to achieve organizational goals. If there is a sense that the school is primarily one where people are Congenial (but not terribly productive), it may be necessary for the leader to begin demanding more specific outcomes that create a need for more individual, goal-focused behavior which may move people toward getting the job done along with maintaining close and respectful relationships with coworkers. If the school has an abundance of Competitive behavior, it is important for the leader to insist on less competition and more creation of positive interpersonal relationships so the level of togetherness can be increased.

The previous set of recommendations on how to move a school or any other organization closer to the status of full Collegiality may have some value in an ideal world where virtually everybody in the organization falls into one of the four quadrants. In reality, all organizations tend to have great diversity with regard to the kinds of groups that are represented among the Four Cs. There will be some groups in the organization that resist coming out of the Cocoon, while a healthy mix of teachers are likely to be either highly Competitive or extremely Congenial. In fact, some organizations also have a healthy dose of individuals who are

committed to Collegial patterns of professional behavior. The worst mistake any leader can make is to assume that everyone in the school is found in one quadrant or another.

Because you are likely to find the mix of styles and behaviors that includes all four quadrants, you need to be able to work as an analyst on all the strengths and limitations of all different perspectives if your goal is schoolwide in nature. Congenial teachers can work side by side with Competitive coworkers, and those who live in the world of Cocoons might be able to use their interest in being left alone while they continue to teach and service students quietly and effectively. Your job as an effective school leader is not to force acquiescence by each faculty member, but rather to present the most positive image possible for the broad perspective of learning communities and then support each individual faculty member in building on his or her personal strengths as a contributor to the larger school mission and goals. Clearly, that task will be difficult to carry out. But having a lens such as the Four Cs may be an important tool to use in your efforts to create a shared vision of a school operating as a community.

RETURNING TO MANCHESTER

Reflecting on the scenario that opened this chapter, it is clear that Principal Marsha Fields has an enormous challenge facing her. She has only one year to turn around a school that is in a deep hole. As she discovered rather quickly at her first faculty meeting, she is faced with the serious challenge of changing what might be described as a highly toxic culture to a professional environment, where students are no longer the scapegoats responsible for failure but rather are the clients of the school who deserve treatment and the best customer care. Marsha must first address the following: Who are the faculty members she has inherited, and where can she begin her transformation of Manchester from a model of failure to a model of success? And as the new principal knows, the clock is running; the change must at least be well defined and under way within about 10 months.

Three years after her first faculty meeting, the "real" Marsha Fields was still working as the principal of Manchester Middle School. She admitted that she was ready to throw in the towel after that first day of listening to all the reasons why Manchester can't. She came to understand rather quickly that most of the negative comments that she heard from the faculty her first week came from a minority of the staff. She was able to determine the real core of her team within a month after her first challenge for improvement came along. She discovered that she suddenly had

given a voice to many teachers who were Cocooned at the school for years. When she began to see that she was not alone in her search for a better school, Marsha carried out a series of rather deliberate actions that have now been understood as the foundation for the change that is currently becoming increasingly evident in what used to be the worst school in the district.

1. She took swift and aggressive action to transfer the most outspoken naysayer teachers to other schools. She discovered quickly that she had some very good teachers who had just lost track of the possibilities in the school and convinced many transferees that they would be happier in other settings. Surprisingly, she was grieved by only one teacher as a result of her "housecleaning." And that one person chose to retire from teaching rather than keep up the fight.

2. She brought in new and very positive teachers to replace staff that left. These new teachers were not necessarily only new hires but rather teachers from other schools who saw opportunities at Manchester, not just obstacles.

3. Teachers began to meet weekly as a whole unit. The sole focus of these numerous but short sessions was on brief descriptions of good things that happened this past week here at Manchester. Gradually, the meetings were opened to non-certificated staff, parents, and community members. Positive statements were strictly restricted by time considerations. By the end of the first school semester, however, each person who attended the meeting was able to share at least three reflections on good things.

4. Marsha adopted a policy of sharing all that she learned throughout the year about the school's future with teachers, staff, and parents. Care was taken to share only solid information and not hearsay, gripes, or other nonproductive data.

5. At each point in the year, Marsha made certain to reinforce the work of any individual teacher or team of teachers who were making progress toward changing the culture and climate of the school. Examples grew in number steadily all year long.

6. Marsha persisted with her vision. She was patient but also clear in her expectations that the school would start functioning like a family, where teachers serves as parents, talking about their children's successes and achievements. The school's culture and climate improved drastically and rapidly.

7. Marsha was patient. She also kept the superintendent informed of each success that was seen in the school. Achievement test scores did not immediately improve, but it was clear that scores were heading up at the end of the year. That gave her another year for further development. By the end of the second year, the school actually began to lose some of its negative press and stigma concerning how bad it was. The operative word here is *was*.

After three years, more work would be needed to make the school even better. But Marsha Fields was fairly happy with the progress being made. When asked what the next steps would be for Manchester, she noted, "We have to keep things going. We worked hard to specify our goals, objectives, and our vision for the school. We have been successful in getting everyone working toward the same vision, and above all, we can't get sidetracked. That's why I want to stay here a few more years . . . to keep the energy level up by teachers, staff, parents, and most of all, the kids."

CHAPTER SUMMARY

This chapter included information regarding one of the critical skills needed by an educational leader who would be intent on making important and needed change in her or his school. We reviewed several different models that have been used to assist educators in developing insights to respond to a most significant question facing them: "What's going on here?" It was noted that models from the fields of sociology and organizational psychology have been devised to answer questions about formal structures of schools and other organizations. But even more important have been the developments of ways to understand the informal structure of schools. In this regard, descriptions of work done in the area of organizational climate and health were noted, along with the recent suggestion that organizations can be understood through the application of an understanding of alternative frameworks that serve to guide the analysis of schools. Finally, a new model—the Four Cs Model—was presented as yet another way to look at the alternative cultures often existing in schools. This perspective was introduced to assist educational leaders to appreciate the various existing levels of involvement that traditionally are found in schools, and also identify ways in which the characteristics of different levels must be addressed in moving schools in the direction of becoming true learning communities.

POINTS FOR PRACTICE

- Every school has certain unique characteristics that make it different from all other schools. Examples of these gross and visible characteristics are size, grade levels taught, age of the building, number of teachers, and similar items that can be seen immediately, even from the outside of the building as you pass down the street.
- But schools also have other features that are not readily seen in a quick glance. Words that have been used to describe these more intangible features include the school's *climate* or *culture*.
- Having a culture that is conducive to people forming community is a most important goal of an administrator who wants to create learning communities in the school. We note that there are four different ways of describing existing school cultures: Cocoons, Congeniality, Competitiveness, and Collegiality. Of these, Collegiality is the most desirable model to have or create in a school committed to change and improvement.

REFERENCES

Bolman, L., & Deal, T. (1991). *Reframing organizations: Artistry, choice, and leadership.* San Francisco: Jossey-Bass.

Bolman, L., & Deal, T. (2002). *Reframing organizations: Artistry, choice, and leadership* (2nd ed.). San Francisco: Jossey-Bass.

Getzels, J., & Guba, E. (1957). Social behavior and the administrative process. *The School Review, 65,* 423–441.

Hage, J. (1965). An axiomatic theory of organizations. *Administrative Science Quarterly, 10*(3), 289–320.

Halpin, A., & Croft, D. (1963). The organizational climate of schools. *Administrator's Notebook, 11,* 1–2.

Miles, M. (1965). *Planned change and organizational health: Figure and ground. Change processes in the public schools.* Eugene: University of Oregon, Center for the Advanced Study of Educational Administration.

Studying Your External Environment

<div style="text-align: right; font-size: 2em; font-weight: bold;">5</div>

Pedro (Pete) Maldonado has been a professional educator in the Central City Public Schools (CCPS) for his entire career. He is a native of Central City, and he has spent his entire career in a huge district—a true megadistrict, enrolling more than 250,000 students in more than 400 school buildings in a huge metropolitan area in the Midwest. Pete grew up in a neighborhood on the near North Side of the city named Kenwood Park, an area where the primary language of commerce and daily life was Spanish. He attended Clarence High School, one of 55 comprehensive high schools in CCPS. Pete had a very different background than many of his neighbors and classmates at Clarence. He grew up in a household where his father was Latino and spoke Spanish as his primary language, but his mother was Vietnamese and spoke her native language at home for the most part. As a result, Pete grew up speaking three languages, a fact that no doubt influenced his choice of undergraduate degree and even his career choice. After graduating from the College of Central City, he went to work as a high school foreign language teacher at his alma mater. He truly loved languages and, more important, the cultures of the people who spoke different languages. He also learned French and German as an undergraduate, and he was studying Russian using a home study program on the computer. He was amazingly skillful at picking up different languages.

He loved teaching and spent nine years in the classroom at Clarence High. He was named department chair of the Modern Foreign Language Department after five years and the completion of a master's degree from DeVane University. His dedication as a teacher and his organizational skills made him a natural choice when the local area of CCPS asked him to become a language consultant to the five other high schools in his part of the city, most of which enrolled primarily either Latino or African American students. While he was multilingual, Pete was also one of the few Spanish speakers with the skills and talents that would enable him to help teachers work in their classrooms.

Soon, Pete's leadership skills were recognized and he was asked to think about going through the CCPS Leadership Program. In so doing, the district was giving him the subtle signal that he would soon be working as an assistant principal in a high school if he wanted. He agreed to the opportunity and after only four years in his role as a language consultant, he was assigned as an assistant principal at Blane Tech, a high school that was traditionally a Latino school but which was now serving more and more recent immigrants from Southeast Asia. Pete was quite happy since he could now continue his work as a multilingual specialist, working with families whose traditions and cultures were quite familiar to him.

After nine years as an assistant, Pete believed it would be time for him to look for a principalship in the city. After all, the district was facing a massive shortage of principals due to retirements and in some cases poor performance ratings that were now becoming more frequent across the district due to national and state accountability mandates. Pete had a great record as a classroom teacher, instructional consultant, and most recently as an assistant principal. Moreover, he was linguistically fluent in no fewer than six different languages—a certain bonus for someone interested in a leadership position in a community as diverse as Central City. Pete applied to all nine high schools across the city with openings for principalships next year. One of the schools looking for a new leader was Clarence, his alma mater and the school where he began his teaching career. Besides that, he knew the old neighborhood well since he continued to live in the area after his parents passed away a few years ago. It was home, and he really believed he was the best person for the job.

Unfortunately, the Local School Council that selected the new principal for Clarence had other ideas. They certainly liked Pete, but they wanted someone from outside the neighborhood to come in as the new principal. Besides, there was also a push for a principal who had a doctorate because of the prestige factor. They believed that a person with PhD or EdD after his or her name would be a good catch and an important role model to the students. Pete had only thought about pursuing a doctoral degree some day, but he never had time when that day came along.

Although he was disappointed by not being selected for the job at Clarence, Pete had now caught the bug and really wanted to find a principalship in the city. Now he was thinking that he had the ability to serve any community in the city, so he forwarded his name to the Local School Council conducting a search for a new principal at Hilley High School on the southwest side of the city. He was notified that he was a strong candidate and that he would be interviewed in one week. The main purpose of the interview would be to determine his vision for the students who came to Hilley from the Riverport neighborhood where Hilley High School was located. Pete read the e-mail from the Council and was happy to know he was still being considered. But he knew that if he had any chance of getting the job, he had to learn a lot more about the Riverport area. He had heard of the community, but he had never been there or really cared much about it. He was a northsider, and Riverport was on the south side.

Points to Ponder

- If you were Pete, what would be some of the things that you would like to know about Riverport if you were to become the new principal at the neighborhood high school?
- What would be the most important thing that you could learn about the neighborhood if you were to accept an offer from the Local School Council?
- What might be some of the things that you would learn about Riverport that might convince you not to accept the position if it were offered to you?

While many people think that one school is pretty much like every other school of comparable size and grade levels served, that is simply not true. It is not even true when two schools are located in the same school district, in the same city, or even on the same street. Every school is different from all others. Part of that is based on the nature of the people who work in each school. Some places have highly experienced teachers, or very friendly staff members, or extremely unruly students. Of course, school buildings have unique features that might have an effect on the educational programs that are offered within their walls.

Perhaps even more important for the school leader, however, is that each school is located in a very different community from all others. And there is little doubt that the external environment of a school probably has an even greater impact on the leader than what goes on inside. Street crime around a school might mean drugs are being sold near, around, or even in the school. Students are often afraid to come to school when local gang wars are active. Political groups in the neighborhood must be recognized as influential on the practices of the school. The same can be said about churches. The businesses near your school can either be a great support for your educational goals or can result in huge problems that will affect the lives of students and their parents.

In this chapter, we will look at the work that was done by Pete Maldonado as he prepared for his interview at Hilley High School. He carried out an analysis of the Riverport neighborhood to help him understand the kinds of parents and community members with whom he may be working in the future. Besides preparing for the job interview, this type of community analysis is something that every school leader needs to do from time to time, even in settings where the principal might already be familiar with a particular school.

Practical Tips

Learning the Local Landscape

It is very important that a principal would have a good understanding of not only the school in which he or she works, but also the neighborhood or community outside the school's walls. Here are some tips to help you in gaining a better understanding of the world around your school:

- **Learn who's who.** Analyze your community to understand who the local power brokers are, identify influential local organizations, and determine who are the real supporters of public schools.
- **Follow the political roots.** Learn the political leanings of your new school community, and look into the history of the neighborhood so that you can understand current behavior.
- **Tap into experience and expertise.** Talk to former local administrators to understand their take on the community.
- **Do your homework.** Start reading the local newspaper for clues as to issues that are likely to face you when you step into your new office.
- **Keep your ears and eyes open.** If possible, visit local businesses and listen to what people are saying about their schools.

ANALYTIC FRAMEWORK

As we noted in Chapter 4, one of the more recent conceptual models to assist individuals in determining the issues, problems, strengths, weaknesses, and many other similar characteristics of an organization is the organizational frames identified by Bolman and Deal (2004). This conceptualization suggests that there are four different ways or frames to identify the nature of a particular organization: the structural frame, the human resource frame, the political frame, and the symbolic frame. For the purpose of the process serving as the basis for this chapter, we will assume that the Riverport neighborhood in Central City will be analyzed according to each of these frames. As you proceed through the reading of this material, you will be invited to analyze your current school or any other school in which you may have an interest in the same ways demonstrated here.

HISTORICAL THUMBNAIL FOR THE RIVERPORT COMMUNITY AND HILLEY HIGH SCHOOL

A brief historical description of the area of interest is important because it provides a context and foundation for what things look like at present. A school that is only a few years old in a suburban community that was a cornfield just 10 years ago is very different than a school that has served an urban community for more than 100 years.

Hilley High School is by no means the newest or shiniest school among the nearly 400 schools in the Central City Public Schools, 55 of which are senior high schools (Grades 9 through 12) like Hilley. The high school is among the oldest facilities in the entire system. It was opened in

1882, and one of the attendees at the school's opening ceremony and dedication was Dr. Josiah Hilley, the school's namesake and a local physician known widely as a man committed to serving the working poor in the stockyards and meatpacking houses in the Riverport community. He had also been a heroic figure when he saved many Union soldiers' lives during the Civil War. At the time it was first opened, the school was located in an open prairie south of the main part of Central City. The area became known as Riverport, namely because it had docks on the South Branch of the Central City River, an important waterway that linked the Great Lakes to the north with the Mississippi River to the south. At one time, there were several storage warehouses that formed a kind of port. As years went on, the area became the home of many small factories and a large stockyard and meat processing center. Riverport in those days was a busy, dirty, and foul-smelling part of the world. Hilley School was for many years the only school building in the area, and it was at the center of Riverport.

There have been significant changes in Riverport since it was first settled as a small town south of a large city in the 19th century. For one thing, it is now part of Central City. It is truly an inner-city community where one can stand on many of its street corners and see the skyline of the major metropolitan area of which it has been a member for many years. Other communities have grown up adjacent to Riverport, yet as is true across Central City, the small towns of the past are now neighborhoods integrated into the cityscape but retain a sense of small-community life. Central City enjoys a national reputation as a "city of neighborhoods"; if asked where they come from, most residents of the larger city say immediately that they are from Riverport, Lakeside, The Yards, or any of several dozen communities which are a part of Central City. The stockyards are now long gone, and many of the small factories have moved to distant suburbs or rural communities around the United States or elsewhere. The most recent development of Riverport is that it has increasingly become gentrified. The old neighborhood has attracted many suburbanites who find that it is much more economical and practical to live in a community where they can take advantage of mass transit and a short commute into the central business section of Central City.

Points to Ponder

- What might you say in response to a challenge to provide a brief history of the community in which you find your current school?
- What is the value of learning about the history of a city, neighborhood, suburb, or small town?

STRUCTURAL DIMENSION OF RIVERPORT

The important thing to remember in the section dealing with structure is that this perspective might best be defined through the phrase "just the facts." It might also be called the "encyclopedia description" of the community. It includes very specific data such as the size of the community, the population, location, main businesses, and other items that can be gathered from sources not requiring the user to even see the area in person. Information should also be included about the specific school of interest to the person developing the community description.

As it now stands, Riverport's population is made up of approximately 35,000 people who live in a five-square-mile area (the neighborhood boundaries make the area about two miles across from east to west, and about two-and-a-half-miles long from north to south). Such data is not precise because neighborhoods across Central City are not absolutely confined by the work of surveyors. With the exception of aldermanic elections to the city council, most people are happy to modify geography in their own minds.

The neighborhood is filled with small, single-family houses and many three-story homes where each floor operates as an independent apartment from the others on the same lot. In Boston, such dwellings would be called "triple deckers," and many such buildings in New York are "brownstones." In Central City, they are "three flats." A drive through the community today would show that there are numerous empty lots and churches, taverns, houses, and small stores over which there are single-family apartments, in most cases because the family living in the apartment owns and operates the stores over which they live. As noted earlier, the neighborhood was also once the home of many small factories, and also the world headquarters of a huge mail-order retail company, meatpacking houses, rendering plants, and the single most nationally known landmark, the baseball park in which an American League professional team has played for many years. Meatpacking houses, rendering plants, the large retailer, and the majority of factories have left the area in recent years, but churches, single-family residences, taverns, and of course, the baseball park remain.

Hilley School has gone through many changes over the years. When it opened more than 100 years ago, it enrolled slightly more than 300 students, mostly Grades 1 through 5. As high school education became increasingly important as the world moved into the 20th century, Grades 6 through 12 were added to the school, and the enrollment in the building increased to over 800 students. Additions were built to the school to

provide more space. Finally, just before World War I, two more elementary schools were constructed in Riverport, and Hilley was designated as a high school. While there have been several remodeling efforts directed at the inside of the school, the building still looks much like it did at the end of the 19th century. It currently enrolls approximately 2,000 students, many of whom come from neighborhoods outside of Riverport.

One last thing about the structure of the neighborhood that is linked to history is important. For most of its history, Riverport functioned almost as if it was a town in and of itself. It had been annexed into Central City in the late 1890s, but a greater majority of the people residing in the neighborhood rarely had to venture out to other communities in the metropolitan area. The horse-drawn streetcar line was not extended into the community until 1898, and so people learned to live in their own community. Most people could (and did) live their entire lives in Riverport. There were no hospitals in the community, but doctors resided in the neighborhood to provide health care and oversee the home births of many Riverporters. People lived in the neighborhood, worked and shopped in the community, worshipped in one of the many churches in the community, went to their local taverns for entertainment, and eventually died in Riverport. The only thing they could not do in the neighborhood was to be buried there. There has never been a cemetery in Riverport. Migration to other parts of the city began with the Great Depression when people had to look to surrounding areas for jobs. World War II meant that many Riverporters went not only around the area but around the world. And ever since World War II, people lived in Riverport but they became much more involved with Central City activity. But they tended to come home every night after work to their favorite neighborhood pubs and the homes that were in their families for many generations.

Points to Ponder

- How would you describe the basic structural characteristics of the community in which your school is now located?
- Which, if any, of the characteristics of Riverport stand out as particularly important to you if you were to become the principal of Hilley High School?
- What would you expect to be some of the issues that you might face if you were to assume the principalship of Hilley High school or any other school in the Riverport neighborhood?

HUMAN RESOURCE DIMENSION OF RIVERPORT

Regardless of what a community might look like on paper, simply understanding structure does not tell the full story of what an area is likely to face in terms of probable issues and challenges. Simply stated, to understand the Riverport community, one has to understand Riverport people.

According to recent census data, the ZIP code that makes up most of the Riverport community in Central City may be classified as a community filled with working-class, blue-collar, lower-to-middle-income residents. The education level of most residents is a high school diploma, although there have been a few rare cases where people went on to college or further professional and graduate degrees. Most community members did not receive their high school diplomas from Hilley High School. Instead, they went to different church-related (usually Roman Catholic) high schools found around Central City.

The prevailing ethnic make up of Riverport was traditionally Irish and Lithuanian for many years. Historically, Irish residents became police officers, firefighters, and above all, politicians. Lithuanians (who could not speak much English when they arrived in the United States at the turn of the 20th century, or as displaced persons after World War II) operated small businesses that catered to other neighborhood Lithuanians, or they worked for the Central City Transit Authority (CCTA) as streetcar drivers or mechanics. But after World War II and particularly in the last 30 years, the ethnic composition has changed to include many more Eastern Europeans (Poles, Hungarians, Bulgarians, Croatians, and Russians), Asians (mostly Chinese and Vietnamese), and since the early 1970s, a large Latino population coming mainly from Mexico. The one group that has traditionally been lacking from the neighborhood in numbers that would equal the population of the surrounding neighborhoods of the south side of Central City has been African Americans. To its great shame, the neighborhood of Riverport has been a place known to accept the presence of African Americans only if they are waiting for buses at major intersections or working in small factories around the community. The unspoken code has historically been that members of Central City's largest minority population have not been welcome to live in Riverport. This started to change in recent years, but it remains one of the least attractive characteristics of a community where families, churches, and traditional working-class values have been part of the social fabric for nearly 150 years.

Despite the limitations noted in the tolerance and openness of the community, Riverport is still known as a good place in which to live and raise a family. And most families are Catholic. There were over a dozen separate Catholic parishes in the neighborhood until economic problems forced

several parishes to close. Most parents still believe that they are obliged to send their children to local Catholic elementary schools and high schools.

There are poor people who live in Riverport, but the amazing reality of life in the community has been the sense for many years that no one realized that they were poor. Riverport has had its own sense of reality; the rich people who live on the north side of Central City have always largely been invisible to the residents in the blue-collar world of the city's south side. For the most part, residents of the Riverport community could have traditionally been called "working poor" had that term been popular for the past 50 or 60 years.

Even the residents who have good, steady jobs are mostly hourly employees or people who have really good jobs because they are police officers, firefighters, or have city jobs granted to loyal Democrats—the only political affiliation that anyone in this area would ever choose. Store owners and bar owners probably have consistently made more money than most other residents, but they were often invisible because they often had their businesses open from dawn to late night, six or seven days each week. In other words, the wealthy of Riverport were not in any continuing social networks, and they were simply not movers and shakers in the community.

Until about 1990, the families who lived in Riverport lived in the houses established by parents, grandparents, and even great-grandparents over the past 100 years or more. Riverport is still an old-fashioned type of neighborhood, where people tend to have roots established in the community and they simply do not move away to other states, cities, neighborhoods, or even suburbs of Central City. Houses and other property tend to stay as family property for many generations. It is still a neighborhood where children move into parents' houses even after being married so that Grandma or Grandpa can be with the kids.

The most recent development in Riverport has been the return of the neighborhood as a very desirable location for "outsiders" (i.e., people who did not grow up in the neighborhood) to buy homes. As Central City workers have grown tired of paying some of the highest gasoline fees in the country and commuting one or two hours (each way) to bland suburbs that are little more than former farm towns up to 100 miles away from downtown Central City, they suddenly realized that living in what used to be a poor southside neighborhood like Riverport would be far better than spending half a lifetime on expressways. Now a walk through the neighborhood will reveal older family-owned houses with many remodeled or newly built residences that are on the market for a million dollars or more—a fact that most Riverport residents find amazing.

To summarize the human resource dimension of Riverport, it is a place that is almost an anachronism, where traditional family values are

firmly rooted. People have simple jobs and simple lives. Residents were not aware of stock market or global market issues that led to changes in the U.S. national economy recently until people started to be laid off from jobs that always seemed to be predictable and safe. People go to church regularly, go out for dinner to family restaurants every once in a while, have a beer at a local tavern now and then, and cheer for the local baseball team during summers. A big family vacation might involve a trip to a theme park or a visit to a relative who grew up in the neighborhood but left a few years ago to move to some other part of the country. Riverporters would never see themselves as racist, but they are afraid that people from "other neighborhoods" are going to come in and take over their island filled with every group except African Americans. They do not see this as bigotry. Instead, they see their efforts as heroic work to keep their neighborhood, families, and lifestyle safe. And for the most part, there is little connection with the world of public education, even if Hilley High School is located on their "island of safety." This may change in the near future if economic conditions make it more unlikely that most Riverport children can no longer afford the tuition of private schools.

Points to Ponder

- Would you consider taking a job as a public school principal in this neighborhood based on the description of the people and lifestyles presented here?
- Would you consider living in Riverport if you were the principal of Hilley High School or any other public school in the neighborhood?
- What would be some likely challenges that you would face if you took a job as a principal in the neighborhood of Riverport?

POLITICAL DIMENSION OF RIVERPORT

Regardless of the structure of a community or the people who reside within its boundaries, there is political activity that takes place. "Political" does not necessarily mean partisan politics but rather a broader notion of how people engage in efforts to control scarce resources such as money, influence, or power. It is critical for any school leader to understand the movers and shakers in the environment surrounding a school.

Many lifelong residents of Central City (like Pete Maldonado) are somewhat familiar with Riverport. They have always heard that it is "the Mayor's neighborhood." Since 1938, there have been only eight mayors of Central City. Five of those mayors have come from Riverport. Included

in that list is the current mayor who will soon complete 28 years in office. He has broken the previous record of nearly 20 years in office, a mark held by his late father. But not only do mayors seem to come from Riverport, so do police chiefs, fire commissioners, police captains and detectives, fire station captains, and every other sort of "big shot" in city service and government. That type of political clout has been evident for many years across the entire city and even the nation.

Riverport and its political clout is a case study of how apparent financial splendor is not necessarily the same thing as political power. As noted earlier, the neighborhood is filled mostly with people who have good, steady jobs, but very few people (if any) have resort homes in Florida or Colorado, their own airplanes, or collections of luxury cars. Riverport is a blue-collar community where people work hard and spend time with their families. But the political heritage of the community is powerful. Over the years, nationally prominent political figures such as Adlai Stevenson, John and Robert Kennedy, Bill Clinton, and most recently, Barack Obama have found it wise to tip their hats to the political prowess found in the neighborhood. Riverport votes and knows how to get others to vote in ways that are consistent with the agenda of the Democratic Party.

In addition to the formal, established political networks that make Riverport what it is, there are numerous local characters who are never left off lists of VIPs in local events such as opening day at the baseball park. One is Jack Twombly, the 90-year-old restaurant and bar owner who runs Twombly's Tap, directly across the street from the offices of the city council alderman who represents Riverport. Twombly's has been the scene of many midnight meetings long after the offices across the street have been closed. Tim McGraw is another extremely important person in the neighborhood and, as a result, across the state and nation. He is the latest family member of the McGraw Funeral Home that has been operating out of the same building in Riverport for well over 150 years. Tim has been the director of funerals for many high-visibility people such as former mayors, congressional representatives, cardinals, and numerous other celebrities not only from Riverport, but from across Central City and elsewhere. As Tim has learned over the years, when people come to his business for wakes, they carry on many important off-the-record discussions that end up as headlines in tomorrow's newspapers. Some of the local politicians without portfolios have died recently. One was Ed Spillman, the sole owner and barber for many years at Spillman's Barber Shop on the busiest street in the neighborhood. Before he died at the age of 92, he spoke frequently of two things. One was about the antique barber chairs that his father had rescued from the demolition of one of the pavilions at the 1892 World's Fair that was held in Central City.

The second thing was about the number of local and even state and national politicians who came in for a shave and a haircut for many years. He would smile often about how people relax in a barber chair and talk about a lot of important things. He freely admitted how these sessions were open and how he could often influence people. "Even the toughest politicians listen to a guy with a straight razor in his hand" would be one of his favorite observations.

If there is one way to characterize the Riverport community in terms of political realities, it would be quite simply that the neighborhood is truly a laboratory for the old phrase "It ain't what you know; it's who you know."

Points to Ponder

- How would you describe your current neighborhood or surrounding community in terms of political life?
- Based on what you saw here, if you were a principal in the Riverport community, how could you make use of resources in this neighborhood to help your school?
- Would you like to work in a school that was in this community?

SYMBOLIC DIMENSION OF RIVERPORT

Bolman and Deal (1997) describe the symbolic dimension or frame as one that "treats organizations as tribes, theaters, or carnivals. . . . [Organizations] are cultures that are propelled by rituals, ceremonies, stories, heroes, and myths than by rules, policies, and managerial authority" (p. 14). Aspects of the Riverport community certainly correspond to this most unique perspective of the community surrounding Hilley High School.

There are no haunted houses, ghosts, or similar sorts of remarkable features that highlight the symbolic nature of this blue-collar community. There are legends, of course. One that young people tend to proudly share with kids who come to Riverport for a visit is that "there were once upon a time at least 10 taverns in every block here." When visitors note that there are very few bars left, the response is always the same: "Central City law requires that any place serving alcoholic beverages will lose its liquor license forever whenever a murder takes place in a tavern." One can always see the visitors beginning to think, "If there used to be 10 bars per block, and there are now only two or three bars for every six or seven blocks, lots of murders happened here. Tough neighborhood." At this point, Riverport kids inevitably feel a sense of local pride because the

death rate is amazing to outsiders. Unfortunately this story, like most urban myths, was based on falsehood (the city does not require a place to lose its license forever), and too many bars meant that many of the establishments went out of business because their owners went broke. But the legend continues.

Riverport has an abundance of heroes. In addition to others noted in the political analysis, one must appreciate the Delaney family and its status as an iconic presence in the community. The current mayor of Central City is Louis Delaney, the son of the famous Louis Delaney, Sr., mayor of the city for nearly 20 years. Louis, Jr., now has gone well beyond his father's service time. In addition to these two powerful men, two other brothers are local heroes. One is Danny Delaney, former Secretary of Health and Human Services in the last Democratic president's cabinet. John Delaney is a county commissioner. But perhaps the most famous Delaney of all was Louis Sr.'s widow, Marge. She continues to live in the neighborhood, in a small bungalow typical of many other houses in the community. She is truly a most honored and respected elder of the community who has experienced so much of the history of this area.

Another legendary character, if not exactly a hero, of Riverport was Al Capone, the infamous leader of organized crime in the Midwest. A warehouse just down the street from the McGraw Funeral Home was the documented site of Capone's brewery that served many thirsty southsiders for years until it was closed following Big Al's death.

So many small stories and big personalities have contributed to so much in this true urban community. The pages of several books written by local authors have been read for many years, usually giving Riverport other, more exotic names. Some stories were exact reports of specific events, while others are simply fiction. But the fact is that Riverport has been an important part of a huge mosaic that makes up one of the greatest cities in the country—Capone, Delany, and all the others real and imagined who breathed life into this collection of old homes, older families, and constant life.

Points to Ponder

- What are some of the things that you would point to as examples of the symbolic dimension that would describe the community in which your current school is located?
- What aspects of this symbolic description of Riverport give the best description of Riverport?
- Who are some of the heroes in your current school's community? Why are they so honored?

BACK TO PETE

After gaining the insights that Pete Maldonado acquired by doing an analysis of the community surrounding Hilley High School, he had a number of important questions that were derived from his review. For example, if Hilley is located in Riverport, and the student enrollment is listed as 75 percent African American, where do most of the students actually come from? And if there is evidence that the Catholic parents cannot afford to send their children to Catholic high schools due to economic circumstances, how will that affect the boundaries for Hilley? Perhaps the most intriguing question that he had was, What would the impact of having a school in a highly political community have on his ability to provide leadership to the school?

The analysis will provide information to a leader (or potential leader), but each person must make a choice with regard to what to do with the information. Pete decided to proceed toward trying to serve as the new principal of Hilley. He succeeded and the Local School Council recommended him unanimously to the superintendent as their choice. Pete does not expect that all of his questions could be answered now, but at least he felt secure in the knowledge that he had some good ideas as to where the "land mines" might be in his future. He was aware that potential political interference might be headed his way, and that if there were more local students attending the school, there may be some great changes in attendance areas, and that may lead to some racial tensions in the school and the neighborhood. He also knew that any school with a lot of police and city workers' children would likely feel the wrath of some occasional threats heard in phrases such as "My old man is a cop and you better not" But it was a challenge. The community was diverse enough that his linguistic skills were likely to come in handy. But being a northsider in a southside school might mean keeping his choice of favorite baseball team to himself.

CHAPTER SUMMARY

This chapter provided an example of how the use of Bolman and Deal's organizational frames might be used by an applicant for a principalship to assess the nature of issues one would likely face in a new school. But more important than that immediate value is that ongoing review of the surrounding community is critical for any school leader. Knowing that a local company that employs several hundred community members is likely to close means the loss of many jobs for parents and other community members. Changes in real estate prices may

signal the arrival of many newcomers. Closing churches can be as devastating to some communities as closing a hospital may be in others. And if a large grocery store closes its doors, that will signal a major hardship for many in the community. All of these events will not stay out in the community. They will quickly affect the students in your school and the lives of your teachers. Indeed, the walls of the school house open in as well as out.

POINTS FOR PRACTICE

- No matter how well you think you know a particular school or community, as a principal it is important to keep learning as much as possible about the key features of the people, events, and issues that are likely to surface and affect your ability to lead your school.
- The four frames for organizational analysis developed by Bolman and Deal provide great information that may be used by a successful school leader.
- The characteristics of the community are as important to understand by an effective leader as the backgrounds and previous performance records of the students in a school.

REFERENCES

Bolman, L., & Deal, T. (1997). *Reframing organizations: Artistry, choice, and leadership.* San Francisco: Jossey-Bass.

Bolman, L., & Deal, T. (2004). *Reframing the path to school leadership* (2nd ed.). Thousand Oaks, CA: Corwin.

Working With Community Groups and Parents

6

"I survived!" That was the one thing that came to Janice Archer's mind as the last reflection on the meeting just completed. The meeting had been with a large number of Cheshire Elementary School parents and community members from the town where the school is located. Janice was an experienced school administrator, with six years as a successful assistant principal, and now she was about halfway through her fourth year as the principal of Cheshire, a large school with an extremely diverse student body in an established attendance area in the Spring Flower School District. She had always had a reputation as a leader who valued the ideas of parents and other community members. That was because, even when she was an assistant principal, she was instrumental in starting what she called School Town Meetings, a time once each month when the doors of her schools were opened to anyone who lived in the attendance area of her school, whether they were parents of children in the school or not. This action reflected a serious value that she had always had going back to the time when she was a politically active high school student at Crewe Station High School in the Spring Flower district where she now worked. She had a longstanding belief that public schools had a moral and ethical responsibility to do whatever is possible to engage the public. As a young student, she worked tirelessly to form communication links between parents and their children's schools by volunteering hours of her time to create newsletters and cable TV programs to provide information to the community.

Janice continued her commitment to dialogue with parents and the community in her teaching days. In her 11 years as a classroom teacher, she went out of her way to engage parents as co-educators for their children. She would make home visits in many cases, and she was known as a teacher who made regular contact with parents to tell them about progress their children were making in her class. She would regularly call parents simply to tell them nothing but the good things that she was noticing about their son or daughter; that she would do this shocked most parents.

When Janice was offered her first position as a school administrator, it was largely because she was seen across the district as someone who could build needed bridges

with community groups, parents, and others. In six years, she was assigned to three different schools, primarily because she had such a strong track record of being able to smooth tensions between local schools and communities. Her efforts at the School Town Meetings were appreciated for a lot of work that seemed to pay off with regard to community support for local schools.

When the principalship at Cheshire came open, she was a clear favorite for the job since the Cheshire community had a reputation of one that was very antagonistic to their school. When Janice told of her intent to bring the School Town Meeting along with her if chosen as the Cheshire principal, that sealed the deal and she was recommended to the superintendent as the community's choice as the next principal. He agreed and she started work in her school three years ago this past July.

The first few School Town Meetings in her initial year were very well attended. In the recent past, less than one-third of local parents came to the school for any PTA meetings or Parent Night gatherings. But the new approach to encouraging community members to come to the school and simply ask questions of the principal and express concerns seemed so appealing that the first three or four meetings attracted standing-room-only crowds of parents. Comments were quite positive from the community and centered mostly on the observation that the new principal's meetings were truly an invitation for the community to express their concerns and not follow an agenda set by the school. The first few months saw the school's all-purpose room filled to near overflowing. But as the years progressed, the attendance at the meetings held faithfully on the first Tuesday of each month fell off. Predictably, few parents appeared at the December meetings because of the holidays, and the last sessions of each school year, in May, rarely had more than a handful of parents showing up. Janice could not always be present each month, but the assistant principal, counselor, or teams of teachers held down the fort regardless of the number of community members who came to the school. It was clear that the novelty of an open school dialogue was losing steam and by the last meeting of the last school year, Janice began to wonder if the meetings were really worth all the effort any more.

The meeting held tonight, however, recharged Janice's enthusiasm for the open discussions and question-and-answer gatherings. The attendance was equal to or surpassed the crowds at the first few meetings four years ago. Janice knew that this was likely to be the case because of a number of factors. First, during this past summer, there had been a few headline-grabbing events that caused a great reaction among Cheshire parents and others. There was also a widely publicized revelation that one of the custodians at Cheshire was being investigated for possible child molestation at the last school in which he worked. The investigation concluded with a finding that the charges were unfounded, but there was a feeling that there was still need to worry about the safety of children at the school. Second, there had been a horrible case of a child from the school being murdered after being abducted from a park near the school. It was a tragic and traumatic event that shook the entire community. Janice and most of the teachers attended the memorial service that was held a few weeks ago, but the event occurred off school grounds in late June, after the school year had ended. But the trauma continued. Third, test scores had dropped at the end of last year. While many realized that the decline had more to do with new test reporting procedures that now also included more recent out-of-district transfers than before, parents saw the data in the newspaper as a cause for concern. And finally, the recently

announced closing of the Sleepy Time Pajama Factory—the single largest employer in the Cheshire attendance area—had serious negative financial implications for the parents and other community members who would soon be out of work for the first time in many years. People were waiting to get into the School Town Meetings almost an hour before the school was opened at 7 p.m. on the fist Tuesday in September. Janice and other staff members knew it was going to be a long and rough session.

Fortunately, a time limit for each Tuesday night meeting was always rigidly enforced ever since the School Town Meetings began. This rule was applied to tonight's meeting, but predictably, there was some negative reaction by some in attendance who knew the rules but still wanted to have their say. But Janice was satisfied that productive dialogue would no longer be possible after the 9 p.m. ending time.

When Janice got home that night, she did not sleep. On one hand, she was energized that her vision of open dialogue with the community was alive and well. On the other hand, she knew that a lot of questions were still out there and closure would be needed if the school year were to be successful.

Points to Ponder

- What is your assessment of the practice of a school promoting open questioning and discussion by parents and community members on a regular basis throughout the school year?
- What should Janice do about the next few monthly meetings?
- How do you believe the principal and school staff should respond to the discord seen at the most recent School Town Meeting?

Public school educators know that a big part of their success must come from parental support for their work. Bilingual education teachers who work with English language learners are frustrated when they discover that their students go home and the only language they hear in the household is Spanish, even though their parents speak English. And the same is true when parents do not read to their children or "babysit" them with the Cartoon Network each night. Principals and other administrators know the same things about needed parental involvement and support, and they are also acutely aware of how critical positive working relationships are with the local business and corporate community. With increasing costs and lowered taxpayer financial support, it is even more important to seek financial and other forms of support from others with an interest in quality education. Schools do not operate in a vacuum.

While educators and others appreciate the need for positive working relationships with people in their external environments, the seemingly eternal

question is *how?* In this chapter, we consider some answers to that question, but before going much further in that direction, let us reflect on some of the context that leads up to the answer. In other words, before we look at the way to implement solutions, it is wise to consider the nature of conditions that are at the basis of any problems in the first place. We begin with a review of some of the basic issues and concerns that lead to possible parent panic or disengagement, and then we consider some of the concerns frequently voiced by representatives of the larger community surrounding schools.

Practical Tips

Creating Opportunities for Others to Be Heard

Like the Town Hall Meetings used by political candidates, these kinds of sessions can be effective ways to reach out and connect with parents and other community members. But steps need to be taken to ensure that the meetings are viewed as sincere efforts to create communication between the school and the community. The following are some tips to make School Town Meetings effective:

- **Involve your whole staff.** Keep new faces in front of the audience each month. Ask teachers or other staff members to serve as facilitators for each meeting.
- **You are not alone in your expertise.** Never stand alone in front of the group. You are not a candidate on the hot seat. Ask other members of the staff to stand with you as representatives of the school.
- **Play fair.** Never prescreen the audience (or put "plants" in the audience) to make certain that only positive questions can be addressed in ways to make the school or principal look good.
- **Set reasonable ground rules.** Announce at the beginning of the question session that there are time limits for each person asking a question, and also for the length of time for the entire meeting. Also, indicate that only one person at a time may ask a question, and no one may ask more than one question at each meeting.

PARENT CONCERNS

Perhaps the three broadest areas facing many parents across the United States (and, indeed, around the world) these days may be summarized in the following basic questions:

- Are my children safe?
- Are schools addressing the needs of my children as students?
- Am I getting my money's worth out of schools?

Let us consider each of these questions in turn.

Safety Concerns

The shootings of children by intruders at such places as Columbine High School in Colorado, the school in Paducah, Kentucky, and the school in Dunblane, Scotland, were major front-page stories, not only in the United States and United Kingdom but around the world. There can be little doubt that parents everywhere are deeply concerned about their own school-age children

as they watch television coverage of youngsters being led to safety by police wearing full-body armor and carrying automatic weapons into schools so that they could protect the young students and find ways to take out the shooters. There was something wrong with pictures showing shrouded bodies of 8-, 12-, and 16-year-old children

- **Stay the course.** Above all, do not get discouraged by the seeming lack of interest shown by a low number in attendance in some months. Remember that the overall value of the School Town Meetings will be that they are held regardless of size of audience, time of the school year, etc. The meetings must become regular and predictable throughout each school year.

being loaded into coroners' vehicles after being slain by crazed terrorists who entered the sanctuary of schools on regular school days, where the most common commotion of only a few years ago might have been a fist fight between two adolescents regarding a misunderstanding at a dance last Friday night. Who could possibly believe that the sights and sounds from Littleton, Colorado, complete with tense interviews of survivors, would ever be present on the 6 o'clock news beamed around on the world? Kids simply don't go to school and not come home! After the numerous attacks that occurred in the mid-1990s and early 2000s, it was not uncommon across the nation to see students learning such self-defense tactics as how to hide in darkened classrooms, run out of school buildings, or play dead when local police forces would conduct emergency readiness drills to prepare school children in methods not to eliminate possibilities of death and injury, but rather to reduce the number of "kills" that were likely to occur if a shooter got into a school.

Whether it was a result of increased media coverage of horrific tragedies at a few schools or not makes little difference; seeing shootings or hearing of other forms of violence in schools laid the foundation for a great deal of parental discomfort over the most recent several years. No caring parent would not be moved by the televised interview of a grieving parent tearfully stating that she had forgotten to tell her now-dead child "I love you" when that child went off to school that morning. The assumed safe harbor of the local school had been breached forever, and the fears of parents would now come as the most powerful concern in any school community in the world.

When talking about the problem of violence in schools, one must realize that the front-page physical violence of Columbine and other similar horror stories is not the only threat to the safety of children. Verbal abuse and psychological injury can be just as debilitating as the possibility of shootings in or around a school. In the past few years, the problem of bullying by some students has been recognized as a force

that can injure children just as surely as any form of physical mistreatment. The old days when *bully* simply meant one child who was bigger or older than other children in a group who used physical superiority to frighten peers is no longer true. Conventional TV situation comedies like *Leave It to Beaver* noted that to control a bully was simply a case of confronting him with a challenge to fight, which inevitably caused the bully to back down, thus showing his vulnerability. The problem with the bully was no more. Today, however, bullying is a fearful physical and psychological approach to intimidate other children. Bullies are no longer just "big boys." They can also be girls who have no physically demanding characteristics other than the ability to intimidate and threaten others through the use of lies and rumors. Bullies are not necessarily sole characters easily identified by others. In fact, the modern era of Internet access and online communication now makes it possible for "cyberbullying" by nameless, faceless individuals who appear only as screen names to intimidate and frighten children much more than having a tough kid on the playground making threats. There are gangs of bullies who control through the use of lies, promises of violence, or in some cases, serious acts of aggression. Parents as well as professional educators are not always as aware of the ways in which bullies use fear of violence and not simply overt action to control others. But it is present and school leaders must be tuned into this form of activity in their schools.

Add to the concerns over possible violence in schools additional deep worry over student safety resulting from molestation and sexual abuse by school staff. Again, the creation of 24/7 news coverage in recent years has meant that stories which may have been suppressed regarding student abuse in the past appear with all too much frequency on local and even national television news broadcasts. Stories of affairs between both male and female teachers shock audiences on a regular basis. Again, parents must now wonder if their children will not only be harmed through a violent activity perpetrated by an intruder in a school but also by the physical and psychological damage that may be done to a youngster by a supposedly trusted teacher, classified staff member, or even school administrator.

The fact that the question "Is my child safe at school?" is increasingly in the mind and heart of parents means that schools are under continual scrutiny by the public. In the past it was noteworthy if a child came home from school with an injury sustained in an athletic event or on the playground at school. Now, a broken arm or a sprained ankle is a minor concern when, in fact, lives are truly at stake.

Points to Ponder

- How safe is your school in terms of providing limited access by outsiders?
- What procedures are in place to ensure that your school is monitored for unwanted visitors?
- Do you hear of any suspicion regarding the actions of any staff in your school regarding improper contact with students?
- What is your district policy regarding these issues? Does it contain clear definitions of what constitutes improper employee behavior with students? Is it stated, for example, that no employee in the school district shall ever be alone in a closed room with any student? Is it clear that even the appearance of impropriety will be treated as activity requiring intensive investigation by the school district?
- Is there an action plan in place at your school regarding any form of schoolwide violence that might threaten the safety of students and staff? Are steps specifically described in school district policy manuals that shall be taken by school personnel to inform district administration and local law enforcement agencies in cases where violence has escalated or may escalate? If there is a threat that includes potentially lethal weapons, how does policy dictate procedures that are different from two students having a wrestling match out on the playground?

Addressing Student Learning Needs

As both parents and taxpayers who provide financial support for schools, people actually do want more out of schools than merely protecting their children and preventing harm by terrorist school invaders, bullies, gangs, and predators and child molesters. In short, parents also want to think that they send their children to schools to actually learn. And recent political activity such as the reauthorization of the Elementary and Secondary Education Act (popularly referred to as the No Child Left Behind legislation) make it clear that elected officials are keen to at least appear to want to require schools to meet certain externally mandated standards to ensure that parents are likely to see improvement in the learning of their children. The simplest way to provide this evidence of learning or non-learning is through the use of achievement testing: If test scores are high in a school, learning by children was occurring. If test scores are low, the school was not doing its job. To ensure that parents and community members would be able to oversee this form of developing more effective schools and increased learning, a structural dimension has been added to legislative mandates that would theoretically improve the quality of education across the nation. That structural component is the call in each state for

the creation of school-based decision-making groups composed of school teachers, staff, administrators, parents, and community members who would participate in periodic meetings that enable parents to feel that they are active participants in their children's educational practice.

Since these efforts to demonstrate that schools were finally being required to provide evidence of students learning and keep parents in the loop regarding students learning, several developments have occurred. For one thing, the reliance on the results of testing programs as reliable examples of student learning are increasingly being called into question, at least in the minds of many parent groups nationally and locally. While schools and their staff feel compelled to raise test scores to ensure that state and national performance standards are met for student achievement, this means that schools and districts feel pressure to ensure that students perform well on tests. That means afterschool tutoring, Saturday classes to review test materials, and other similar activities that many parents are now beginning to question. Frequently, parents wonder whether test scores may in fact be translated as evidence of learning. And if that is the case, does the extra drilling on test-taking practice and review sessions on weekends and after school really provide an avenue for more effective learning? Often, parents face the reality of young children becoming more disinterested in school because so much of the activity is directed only toward increasing test scores. In short, parents are questioning the use of high-stakes testing as a reasonable activity carried out allegedly in the name of improved student learning.

Second, there is some doubt as to whether the testing process in itself is not actually a way of decreasing student learning. In the eyes of many, so much school time is spent attempting to increase students' test scores on measures of learning that are coordinated with the school curriculum (as defined increasingly by state mandate) that time for advanced learning by some students is actually being decreased. Because performance on achievement tests is being used as the primary indicator of the whole school, students who are well beyond the material needed to pass the test are being held back from progressing to higher levels of learning.

Another limitation of current efforts to prove school quality based on tests is that this process simply provides a rather narrow definition of what student learning is all about. Parents want their children to acquire many important life skills through schooling. Of course, this means the ability to communicate effectively in writing, read well, and engage in fundamental mathematic processing. But parents also hope that the schooling experience is a way for students to acquire social skills, self-esteem, good study habits, interests in different academic fields, and many other similar outcomes that are not tested.

The problem in many cases is that the answer to whether or not parents are actually seeing growth and development in their children is offered with a simple statement that is often driving the school's work. It all depends on the numbers generated during the testing process.

Points to Ponder

- How does your school provide systematic feedback to parents in any way other than through grades in individual classes or scores on high-stakes testing devices?
- How effective do you believe your school is with regard to ensuring that student learning is not defined solely as scores on mandated achievement tests? In some schools, teachers are encouraged to send home monthly or weekly "Class Progress Reports" that do not focus on testing, but rather more general statements concerning what are the high points for whole classes. Another principal that we have met has suggested to her teachers that it would be very good if each teacher would make it a point to contact the parents of at least five children each month simply to let parents know that their children are doing a great job at school; parents are generally quite surprised to get these calls since they traditionally believed that whenever a teacher calls home, it is to require parents to attend a conference about some disciplinary problems.
- How satisfied are parents of students enrolled in your schools with regard to the question of whether or not their children are truly learning?
- How effective is the mandated, site-based decision-making body for your school in terms of how you believe parents are actively engaged in oversight of student learning through this mechanism?

Parents and Their Return on Their Investment

Parents are taxpayers. They have a financial interest in the public schools in their communities. Like anyone with a financial interest in an enterprise, they want to ensure that their money is being well spent. The promise that this question will be answered sufficiently by looking at standardized achievement test scores such as the relative strength or weakness on such visible school outcome measures as test scores may be seen as somewhat limited. Is a certain elementary school a better investment of taxpayer resources because 90 percent of its students received passing scores in reading on a standardized achievement test, as compared to a neighboring school where only 80 percent of the student passed?

Obviously, since schools are judged publicly and politically by how well they perform on certain mandated measures, principals and

professional staffs have a great stake in ensuring that these measures appear to satisfy externally mandated levels of desirable performance. But school leaders must also be attentive to finding alternative ways of demonstrating to parents that their children are, in fact, receiving an educational experience that will meet the expectations of the community, regardless of test scores as but one factor considered. This is a critical role of a principal who must provide ongoing evidence that a school is capable of providing for the safety and security of each student, that the school is committed to serving the individual needs of each student, and that the taxpaying public is receiving services commensurate with the level of investment made by each community. Perhaps the only way for any leader to determine the effectiveness of her or his work in school in these areas is to make certain that methods are in place to consistently monitor community perceptions. Test scores, of course, do not tell the whole story about school effectiveness, but the numbers are important. If they are not to be used as sole measures, the effective school leader must make certain that other ways of assessing public perceptions are available.

Points to Ponder

- What does your school now provide to parents in addition to achievement test data that can give the public evidence of the school's quality? An increasing number of schools are now returning to practices familiar in the past when science fairs were held to allow parents and others to see evidence of student learning through the creation of small science projects. Now, however, schools are carrying out other similar activities to enable parents to see examples of students' artwork, poetry, social studies projects, and many other artifacts that may tell more about how a student is doing in school, beyond test scores sent home in the spring of each year.
- In addition to traditional methods of communicating to parents, such as newsletters and periodic public meetings and open houses, what else is done at your school to keep parents informed about what is happening in their children's school? Other techniques that have worked in many schools across the nation include the use of school Web sites to communicate recent events, future programs, and so forth. Also, an increasing number of schools are making effective use of "robocall" telephone alert systems that are programmed to call the homes of all students enrolled in a school to alert parents and other family members about important deadlines and many other issues that are not always communicated by children when they go home every day.

COMMUNITY CONCERNS

Schools are critical components of any community. As a result, those who reside and work in the immediate environment of each individual school have a legitimate interest in the operation of their local schools. One might argue that local businesses and industries have the same right to know about what is happening in local schools as do the parents who are actually sending their children to each school. In fact, on a financial basis, local businesses may have an even greater stake in the quality of local schools than do parents. After all, taxes collected from the business community are often significantly greater than the property taxes paid by families and other homeowners.

As we observed about parental interests in schools, the wider community has a set of its own concerns used to judge the value of local educational institutions. Two questions that may serve as the foundation for the community's interest in public schools within its borders are the following:

- How do local schools help each enterprise achieve its goals and address its needs by providing local residents with a sufficiently strong education to enable people to work effectively in local enterprise?
- To what extent is our community perceived as a good place to work and live based on the quality of schools?

Of course, as we noted in terms of parents as taxpayers who want to be certain that money is wisely spent on local education, other community members want similar assurance. But there are certainly a few additional concerns such as the two listed above that would apply to everyone in a community, whether they have children enrolled in schools or not.

Are Schools Effective?

This same question is a concern not only to parents, as noted earlier, but everyone who is part of the broad community in which the school is found. Non-parent residents are taxpayers who support public schools. Even if they have no immediate interests in whether or not their own children are acquiring needed knowledge and skills, there is no doubt that no one wants his or her tax money wasted by supporting wholly ineffective school programs.

Local businesses may not champion the needs of individual students going to local schools. But businesses need future employees who can work

effectively in industrial settings. This means that there is an expectation that local schools are successful in teaching basic skills such as reading, spelling, writing (at least basic technical narrative writing), and fundamental mathematics. There is also an assumption that schools are effective if they are teaching future employees good work practices such as punctuality, attention to detail, how to listen and follow instructions, good hygiene habits, and many other skills that separate good employees from those who may be employed by companies but will either need a great deal of immediate remediation to learn what "schools should have taught in the first place" or face dismissal because they cannot cope with the expectations for behaving like an effective employee. Lengthy debate may follow such assumptions by the company that suggests that good employees come from the ranks of students who have learned how to adhere to the needs and expectations of no audience larger than the local factories or other places of business. But it is certainly realistic for companies and others in the school's community to expect that schools which are supported by large amounts of funds provided through taxes paid by local enterprise would be able to guarantee at least that former students can read, write, add, and subtract.

Points to Ponder

- What organizations exist in your school district that would enable a principal to maintain ongoing contact with members of the local business community?
- What efforts are made to inform non-parent residents of the quality of educational programs offered in your community?
- What proactive efforts have been initiated by your school or district to provide information concerning efforts in your school to provide excellent programs to students in your area?

As we have noted throughout this book, being an effective school leader requires many skills and a good deal of hard work. And the walls of a school are not the boundaries of effort to work with the surrounding community. Maintaining ongoing contact with the outside world is a major responsibility of the school leader who realizes that it is truly essential to keep local business leaders, civic leaders, and non-parental adults informed of the efforts that are being made to ensure that the ongoing expectations of the local community are indeed being addressed by the schools. In this regard, the principal of a local school must get out into the community to be both a spokesperson on behalf of the schools and a kind of continuing cheerleader for public education in the community.

Participation in local activities such as the local Rotary Club and sending along guest editorials to local newspapers on a periodic basis are among the techniques often used by school principals to engage in productive dialogue with key members of their local communities.

Community Values and Local Schools

Good schools make property in some school districts worth more than in other areas. Simply stated, one of the top areas of interest for any family moving into a community involves the quality of local schools. If the family moving into an area has no school-age children, interest in the quality of education is not unexpected since good schools are related to the value of homes in an area. And businesses also know that the value of property in which they invest is also a concern for all.

Points to Ponder

- To what extent have home values and prices risen or at least remained constant in recent years? To what extent do you attribute increases (or decreases) to the quality of local schools?
- What strategy might a school staff use to enable local potential investors in your community to see resettlement near your school because of the value that institution provides to all in your community?

No principal wants to spend his or her limited time selling local real estate. However, the more an area has steady or increasing property values means a likely basis of increased financial resources that may be used to increase the quality of local schools. One technique used by many principals across the country in this regard involves making contact with local large realty firms to invite them to send prospective buyers in your neighborhood to come over and tour a school. Answering questions of local realtors is also important. And volunteering your personal time to visit with parents seeking a new home in your attendance area will likely enhance the quality of your school and also your entire community.

RETURNING TO CHESHIRE SCHOOL

Janice Archer has much more to do to enable her school to retain its positive image in the local community. Not only must she respond with solid data and facts concerning the allegations and concerns of the community

in terms of such issues as local crime and the seeming downturns of student achievement success, as noted through lower test scores, but as the principal of a school facing these issues she must also do some rather fundamental things to keep the community on the side of her school. Communication with the local community cannot be a one-way report to the community about what is happening in each local school. Instead, such dialogue must always be of a two-way nature. Not only does the principal of a school need to present his or her side of the story, but active involvement by local parents and other community members must be something that is cultivated and supported all the time. No school can afford to create conditions that will lead to parental lack of involvement in any school. Effective principals know that even having only a very small group of parents to be engaged in schools on a regular basis will likely lead to more effective school programs for all children.

CHAPTER SUMMARY

This chapter identified the importance of any school working toward the creation of open and honest communication with those in its external environment. This means engaging parents and non-parent community members alike so that they feel comfortable with local schools. This necessitates principals becoming increasingly visible and active in local community activities and projects. It also may mean that a new range of activities now face any who look at the administration of schools as being similar to an actor playing to a steady group of audience members each day. No principal today has the blind faith and support of everyone in a local school community anymore.

POINTS FOR PRACTICE

- Parents and community members are not your enemy. There may be many times when you wish that they would not interfere with your efforts, and sometimes they do anyway. But in most cases, your greatest support can come from adults in your immediate community.
- When you become discouraged because parents do not seem interested in helping or knowing about programs at the school, persist. Eventually, you will get a solid core of supporters who will be your strongest allies.
- For the most part, parents care about their children and, even when they seem to be antagonistic about your work, you need to keep remembering that your school is housing the most precious thing in the world for a parent.

REFERENCE

National Association of Elementary School Principals. (2002). *Leading learning communities: Standards for what principals should know and be able to do.* Alexandria, VA: Author.

ADDITIONAL SUGGESTED RESOURCES

Glasgow, M., & Whitney, P. J. (2009). *What successful schools do to involve families.* Thousand Oaks, CA: Corwin.

Grant, K. B., & Ray, J. A. (2010). *Home, school, and community collaboration: Culturally responsive family involvement.* Thousand Oaks, CA: Sage.

McCaleb, S. P. (1997). *Building communities of learners: A collaboration among teachers, students, families, and communities.* Mahwah, NJ: Lawrence Erlbaum.

Sanders, M., & Sheldon, S. (2009). *Principals matter: A guide to school, family, and community partnerships.* Thousand Oaks, CA: Corwin.

Seeing Your
Invisible Heroes

7

Spencer Franklin was very happy to learn that he was chosen as the new principal of Eagle Valley Elementary School, a large school in a working-class neighborhood of a mid-sized city in the Midwest. It was one of 25 elementary schools in the Singing Bird Local Schools, a district with a well-deserved reputation as a good school system. Spencer has spent his entire teaching career in the district and attended Eagle Valley as a student years ago. He was honored to be able to go full circle and return to his educational roots. He was deeply committed to ensuring that the school would become a Highly Recognized School in his state.

Spencer's dream had to navigate through some immediate challenges, however. While the public announcement regarding Dr. Cal Holmquist, the preceding principal, indicated that the local legend had decided to take early retirement to travel with his wife, Spencer had heard through reliable sources that the school board and superintendent were concerned that Cal was running a loose ship, and student discipline, staff morale, public confidence, and, most of all, achievement test scores were all falling. Dr. Holmquist was wise enough to know it was time to leave.

Spencer vowed to himself that his first order of business at his new school would be to tighten things up and make the school feel more professional. During the summer, he noted that teachers were coming to school dressed very informally, and secretarial and custodial staff spent a great deal of time in the air conditioned main office discussing a variety of matters—often not related to school business. The new principal did not want to start off his new assignment by angering the teachers with a dress code for off-duty hours. But he decided that he would make a public statement concerning his commitment to change in the school by addressing the behavior of classified staff.

During the first day of teacher inservice at the end of the summer, Spencer stood in the doorway of his office watching the activity in the outer office. He was happy to see and greet the teachers as they walked in to check where their mailboxes would be located this school year. As a veteran in the school district, he already knew several teachers, but he also offered warm "Welcome backs" to everyone who walked past his open door. He also noticed that each returning teacher made a long stop to talk with Molly Connolly, the senior clerk who was to serve as his personal secretary. She was a part of the culture of Eagle Valley, the only school in which she had ever served in the district. Each person seemed to linger with Molly

as they shared a story or two from their summer activity. Spencer smiled, but he was also starting to plan ways in which this type of informal interaction would soon end at the school. Later, as he walked down the main hallway to the cafeteria where the faculty would meet, he saw Ramon Carson, the head custodian, who was chatting with three other custodians. Clearly, the four individuals were not engaged in any serious business, and the principal made a note that this kind of action would have to be stopped. After all, schools are businesses, and businesses must look professional if they are to succeed.

Points to Ponder

- How do you react to this scenario, particularly if you were working as a teacher at Eagle Valley Elementary School?
- What effect might the decision by the principal to try to change behavior by the classified staff have on the teachers and others in the school?
- How do you think the attitude of the clerks, custodians, and other members of the classified staff would be affected if Spencer were to follow through with trying to changing their behavior?
- What would changes in the staff behavior mean to the school in general?
- If you were the principal and you were concerned about the actions of some of your classified staff, how would you address this situation?

There is an old saying among principals that the two people in your school you do not ever wish to lose as allies are the head secretary and the chief custodian. The logic behind this is quite simple: Secretaries can really help an administrator, but they can also forget to inform the principal that an irate parent just called and is on the way over to the school, or "lose" a file for a few hours, or even allow unwanted phone calls to get into the boss's office. These might seem like insubordinate actions, but they might also be nothing more than mistakes or human errors. You do not want to worry about such matters. Chief custodians can begin to "forget" to clean an area where an important meeting is to take place, or not put enough chairs in a room where a principal will be talking to parents. By contrast, a good secretary can save a principal in many ways, and so can a custodian willing to go the extra mile by staying around after school to make certain that everything is ready for the basketball game, PTA meeting, dance, or a thousand other activities.

Effective schools function as learning communities. This view is guided by the view that schools will always be more successful and effective if they are based on a central vision, namely that the more all members of the organization are involved with key decisions, the better things will be. Everyone who has a stake in the success of a school must feel a sense of ownership in what is going on in the school. The key word in this statement is *everyone*.

Most schools follow a strict hierarchical model of operating. In this view, administrators are on top; teachers, counselors, and other certificated personnel are next; and students respond upward to teachers and administrators. Of course, virtually all schools today also require numerous other individuals to carry out essential activities that enable the administrators, teachers, and students to work toward formal educational goals. These supportive personnel include secretaries and clerks, paraprofessionals, building engineers, custodians, janitors, cooks, cafeteria managers and other workers, security personnel, and numerous additional individuals who come to work in schools each day. Traditional organizational charts of schools often do not even include support personnel, or if they do, they are shown at a level roughly equivalent to teachers. However, in many schools teachers rarely look at secretaries, custodians, and other classified staff members as equals. A review of the vast majority of textbooks about school administration ignores completely the role of support personnel, other than as a group of people that school administrators need to deal with as part of their work assignments each day. While these observations about the ways in which non-certificated staff are frequently relegated to second-class citizen status in schools may be statements of the status quo across the nation, it is almost impossible for any school principal to lead her or his school toward being a learning community if she or he relies on traditional hierarchical patterns.

Broad-based participation by everyone in any organization is likely to increase the effectiveness of that organization, whether it is a business, hospital, university, or public school. When people feel as if they have an opportunity to influence what goes in the organizations in which they work, there is a much greater likelihood of buy-in by all (Belasen, 2000). That factor will lead inevitably toward greater productivity built on a sense that "we're all in this together" or that "this is our place" (Kofman & Senge, 1995). Roland Barth (1990), a well-respected author, former

Practical Tips

Involving Your Whole Team

If you are attempting to develop a collegial culture where everyone is focused on support for learning, it is critical that these heroes in your school be invited to be a part of your community. Here are some things you may wish to consider:

- **Get out of your office and see where others work.** Find a few minutes each day to leave your office and visit nonteaching members of your team in their places of work.
- **Make sure everybody knows each other.** Start the new school year by introducing new full-time members of your staff to the teachers.
- **Learn about people as people.** Learn the names and backgrounds of your full-time non-certificated staff.
- **Activity for staff is for all staff.** When appropriate, involve non-certificated staff in staff development and inservice activities at school.

principal, and founder of the Harvard University Principals' Center, applied the importance of creating buy-in for schools:

> Central to my conception of a good school and a healthy workplace is community. In particular, I would want to return to school that could be described as a community of learners, a place where students and adults alike are engaged as active learners in matters of special importance to them where everyone is thereby encouraging everyone else's learning. (p. 9)

Because each person who works in a school is a key contributor to the success of the school and its students, this chapter is meant to reinforce the importance of making these people feel valued, respected and listened to. A key group that is often ignored in discussions of significant people with the ability to make things happen in a school is composed of people we often refer to as the invisible heroes, who are found in every school in this nation. Heroes include custodial staff, office workers, security personnel, food service employees, paraprofessionals and instructional aides, and everyone else who serves the needs of schools and students every day, but without being classified officially as part of the instructional staff. The list of specific job titles may include others, but for the purposes of this chapter, we only include four broad groups of individuals, mostly because they are almost always found in every school, regardless of size of school or district, or grade level of students served. Virtually any school in which you may work will have security personnel, office workers, food service employees, and custodial staff.

SECURITY STAFF

Schools have long recognized that, while they are meant to be safe harbors where children can learn, there are times when they have not been completely free of any threat to the safety of students, staff, and even visitors. Long before Columbine, Colorado, Paducah, Kentucky, Dunblane, Scotland, and other horrible examples of where the safety and security of schools have been compromised, there have been occasional instances of violence and other forms of crime that have been part of the world of schools. Over the past several years, as the public has become increasingly aware of the potential for bad things to happen in schools, the presence of security officers in school buildings has become increasingly common. In some cases, this role is played by actual armed police officers from local

municipal or county law enforcement agencies, screening admission to schools with metal detectors, searching book bags, and so forth. However, most schools do not feel compelled to have these types of rather severe precautions visible each day. On the other hand, even the most placid and safe communities find it increasingly wise to make certain that a uniformed security officer walks the halls of a school, usually as a visible deterrent to any unwanted behavior. In short, the term *security officers* might be used to describe anyone from a fully armed on-duty city police officer to a part-time truant officer who is responsible for checking on the unexcused absences of a few students each day. And in some schools, no one is assigned the title of security officer.

School security officers are sometimes local police officers working as part-timers when not on official duty. They are, of course, usually unarmed while working in schools, but they are trained in such matters as crowd control and can usually present enough of a feel of authority to deal with most issues that might arise in school. They are also aware of legal limits that guard their ability to conduct searches of students if necessary, or they can also detain individuals because these officers retain their official status that comes with their deputized role as peace officers. On the other hand, school security personnel also come from the ranks of citizens interested in the opportunity to earn money on a full- or part-time basis by serving as visible representatives of law and order in schools. Whether they are well-trained professionals or simply well-meaning individuals who wear a uniform and carry no more authority than being able to use a two-way radio, virtually all school security personnel share the fact that they are not terribly well paid for their work. School districts are often happy to have people who are willing to present some sense of order and calm in a school. At the same time, little tangible respect is forthcoming to those selected to protect schools and students.

Specific Concerns

When questioned about the ways in which they wished that they would be treated by school principals and teachers where they work each day, some of the common observations made by school security officers include the following:

1. We have a lot of responsibility but little real authority.

Security personnel are responsible for ensuring that their schools are safe and secure environments for students, teachers, staff, visitors,

administrators, and anyone else who might be around a school. When there is a catastrophic event such as the shootings at Columbine High School, the first people to be interviewed about their actions concerning "what happened here?" are likely to be the campus administrators and the security officers on duty. In less dramatic fashion, when a student finds his or her locker broken into and discovers some items stolen, again among the first people questioned by parents and others are likely to be the individuals charged with the responsibility to make certain that such thefts do not occur. While the responsibility for safeguarding the well-being of anywhere from a few hundred to a few thousand young people is enormous, the fact is that security officers have virtually no legal authority to do much to intervene directly in immediate problem situations. They can break up fights, but they cannot investigate the causes of altercations. Such final reviews are part of the job description for the school's administrators.

2. I can't do someone else's job.

One of the frequently heard comments by security personnel is that they do not seek to be the first line of discipline in their schools. Often, security officers are expected to be out and about in their schools in a way that will enable them to stop trouble by students before it starts. While it is understood that having someone with a uniform walking the halls of a school will likely serve as a deterrent to major fights, assaults, or thievery, officers note that they really do not see themselves as primary disciplinarians in a school. The mere presence of a person in an authority role will be effective in heading off many problems. However, when teachers have disciplinary problems, their first call for help should not be to a security guard. Handling the vast majority of confrontations concerning the violations of a school's code of conduct should be dealt with by classroom teachers, counselors, or administrators. As it is true outside of schools, calling a cop for every dispute will eventually lead to a situation where even the most minor infraction will take up the time that an officer may need to deal with more serious events.

3. Don't make me the "bad guy"; it's not why I do this job.

Pay for school security guards is certainly not so lucrative as to compel many to go out of their way to seek a job that requires hours of walking around schools as a silent signal that there are people watching out for trouble. The vast majority of school security personnel take their jobs for the same reasons why people continue to go into teaching. They enjoy

working with and for students. There is a satisfaction expressed by many who realize that the presence of a security guard in a school does not guarantee constant safety for all. But there is a pride that comes from the belief that parents can be somewhat secure in the knowledge that someone is keeping an eye on their children each day.

Some security officers in schools become frustrated when they are utilized by teachers and administrators as the bad guys who will be brought in to situations where students are misbehaving or at least being suspected of misbehaving. In some schools, security personnel note that calling one of the guards has the same shock value as calling the guard may have on a prison inmate who acts in an unruly fashion. The reality is that security officers often see their contributions to school life as educative in nature, not punitive.

Points to Ponder

In your school . . .

- Who (if anyone) serves as security officers? Do you share one person with several local schools, or is there one person who regularly works on your campus?
- If you have one person or a team of several individuals who work at your school, do you ever talk with them to learn about their views of the job they are doing? Is this helpful?
- Have you conducted a safety audit in your school with your security personnel to determine potential problem areas needing greater attention by staff? If so, what did you learn?

You may wish to add other items to promote meaningful contact with this group of invisible heroes. The critical thing is always to learn more about the people who serve you and your students.

OFFICE WORKERS

Not too many years ago, it was common to find perhaps only one secretary serving the needs of an elementary school, while larger high schools might need two or three full-time clerks to take care of the needs of a school staff. In recent years, the myriad tasks associated with keeping track of student records, attendance, financial accounts, enrollment

management, scheduling, and a wide variety of other important aspects of school management have created the need for additional staff.

The best way to think about the ways in which you might work effectively with the secretaries and clerks who work in your office is that they are a group of highly competent specialists who collectively possess the requisite skills to perform many, if not most, of the daily managerial duties that are needed to operate a school building each day. They know district policies and procedures as well as state and local laws pertaining to many specific areas related to keeping a school operating efficiently and effectively. As a result, it is critical that you know the exact nature of job descriptions, as these may be negotiated districtwide and be part of the district master contract with non-certificated (classified) school staff members. Of course, the formal job descriptions usually include a common stipulation that clerks and other office personnel may be expected to carry out additional duties identified by the school principal. This does not mean, however, that everyone in the school is expected to respond to every whim of the building administrator.

The people with whom you work are likely to have an abundance of skills and interests that may be of great benefit to your school. The secret in this regard is not found in looking at formal descriptions, or by mandating that individuals do extra work just because you say that they must. Instead, it is critical that any principal get to know office staff—not only on paper, but in person. In some cases, we have found office personnel who may have extensive job experience working in such areas as budgeting or personnel management. We know of more than a few cases where office clerks already possess teaching credentials, and in some cases, they may be drafted to serve as substitute teachers. Remember, too, that office staff members typically have many insights into the needs of teachers and parents that you may not know about as the principal. People are much less likely to seek formal appointments with principals, and so if they have concerns, they often speak only with clerks in the main office. In short, office clerks are often filled with insights, skills, local knowledge, and political savvy that can be a great benefit to you each day.

Specific Concerns

Another way to think through the ways in which you might work effectively with secretaries and clerks around the office is to reflect on some of the gripes that these individuals have identified. Among the issues that are most often identified as problems encountered by office staff are the following:

*1. We are often treated as part of the office furniture
rather than as real people.*

It is often true that a new principal inherits most of the office staff in his or her new school. However, that observation does not mean that you necessarily need to think of the attendance clerk, registrar, business manager, senior clerk, or principal's secretary as pieces of furniture who will always be available to carry out tasks that you identify as important at a particular moment. Of course, you will know the name and background of your personal secretary rather quickly, but there are often many other individuals who work just outside your door and who deserve personal recognition from the leader. An interesting observation in many schools is that teachers often know more about the secretarial staff than the principal does.

A suggestion is that you get to know the people you work with as *individuals* as quickly as possible upon coming into a new work environment. Begin by going through a kind of crash course to learn certain facts.

- Write down the names (and nicknames), job titles, and number of years of experience for each member of the office staff in your school.
- Look at your list each time you go out to workstations in your building so that you get to know names, faces, and histories in this school (and perhaps other schools). It is amazing how quickly people respond positively to simply having another person recall their name.

2. Nobody really knows what we do here.

Again, this observation may not apply to the relationship between you and the person who acts as your immediate secretary or clerk. Within minutes of taking over as the new principal, you probably learned that "what my secretary does" is likely to include many different activities. But what about others who work in your main office? For example, what does an attendance clerk do? What pressures is she or he under regarding the reporting of absences, truancies, and tardies each day? Have you ever stopped to take a look at the forms that must be completed accurately and in a timely fashion to ensure that your school is properly represented in districtwide reporting procedures? Remember that when you sign off on a form or report prepared by one of your staff members, you are in effect committing your reputation (and perhaps job) to the accuracy of anything bearing your signature. You are in the hot seat.

Nobody expects that you, as the principal, will necessarily become an expert in each area of responsibility in a school. But taking the time to learn some of the basic skills that need to be addressed by office staff is a statement that you see individual contributions as a vital part of your school's success.

Points to Ponder

- Do you know enough about the work of your office staff members that you could find an appropriate replacement if your secretary, the business manager, or the attendance clerk phoned in sick some morning? Do you know enough about the work of key staff members that you could even pinch hit for one or more people?
- When staff members go for training provided by the district to assist people with new procedures, policies, or practices, how do you spend some time learning from your staff about the issues that are likely to affect your school?

3. We are often treated as if we have no brains.

Often, office staff report that they believe that students (elementary or secondary) receive greater respect for their intellectual ability than do the members of the staff. Secretaries often believe that they frequently are the last people to hear about new directions for schools. This is not simply a matter of people feeling left out. It is critical to note that, in many cases, the first responders to rumors related to just about anything in the school are the people who first answer the phones. Thus, whether the issue that is being discussed centers on changes in the bell schedule, the adoption of a dress code for students, new curriculum, test scores, increased prices for cafeteria lunches, or just about anything else that may affect children, parents, or the community in general, it is important to keep people who interact directly with the community aware of what is going on. And when controversial matters are being considered by the administration and teachers, involve your staff with honest information about the issues under discussion. Remember the obvious, which so often seems to be forgotten: Although your staff may not have many college degrees or teacher certification, they are intelligent people who can have a tremendous impact on community's sense of whether the school is open, honest, and effective.

There are many other issues that serve to make office staff unhappy. Salaries are rarely commensurate with the responsibilities that people

have in schools. Working conditions are often less than desirable; hot offices that often become filled with students facing disciplinary action, angry parents, and others are found in many schools. The expectations for individuals to carry out critical and complex tasks without much training or support are frequent in many school districts across the country. These may be issues faced by your office staff, but in most cases, they understand that the principal has very little control over such matters as salaries, fringe benefits, or even working conditions. But, like everyone else who comes in contact with your school, secretaries, clerks, and others who work in the office seek only one important type of recognition that will have no impact on your school budget, and that is sincere respect.

Points to Ponder

- What are some additional ways in which you can develop professional relationships with the office staff of your school?
- How can you create an environment where office staff members can work together to address problems and concerns faced by the whole school?

CUSTODIAL STAFF

Principals are like mayors of small towns. They have great power and authority to carry out various required activities in their "towns." Their behavior and attitude are observed by all the "residents" as an indication of how things are going in their schools. They engage in political behavior every day, whether it is with the central office, local community groups, or people in their "towns." But mayors cannot do everything necessary to provide adequate services to all their citizens. That is why communities also hire people to work on street repairs and many other vital municipal services that ensure public safety. Livability and other indicators of a high quality of life must be maintained.

The custodial staff in your school represents the team that makes your school safe and livable. For years, new and aspiring principals have been told that, in addition to the school secretary, the custodian is one of the two most critical people in your school. Like the school secretary, the custodian is a person who can make your life miserable if heating or cooling systems experience problems, plumbing is not fixed immediately, and classrooms are not cleaned adequately. These are worst-case scenarios. It is far better not to view your relationship with your custodial staff as a

kind of insurance policy to prevent disaster. Instead, developing a mutual respect between you and those who maintain your school can have many very positive effects for everyone.

Specific Concerns

Some of the concerns expressed by school custodians include the following:

1. We are not here simply to mop the floors.

The most critical foundation for a positive relationship is the fact that you need to understand that a custodian is much more than the guy who walks around the hallways with a broom and a mop. To be sure, keeping a school clean is an important duty for a custodian. However, sweeping or mopping is not everything. Custodians are not simply janitors. They have many more ways to contribute not only to school cleanliness but overall well-being. That is one of the reasons why custodians have the title that they do. A school is in their custody and care. Perhaps another term that might be used is what the British refer to as *school caretakers.*

Points to Ponder

- During a walk around your school, what activities do you see custodial staff doing around the building?
- Have you ever talked with a custodian to learn what responsibilities of his or her job are most interesting? Why did he or she identify the specific duties described to you?
- List some of the other things that your custodians do each day that go beyond formal responsibilities such as cleaning, arranging meeting rooms, checking on heating and cooling, inspecting the building for needed repairs, and other similar activities traditionally associated with their jobs.

2. We want to be known as individuals.

Custodians want the same consideration from their coworkers that was specified earlier by the office staff. For example, they want to be known by name and recognized as individuals, not just as workers around the building. In large schools, it may be true that it is not easy to know all custodians individually. They often work in staggered shifts, where some custodians arrive early in the morning before teachers and administrators report for work, or they work a shift that starts after the school day has concluded. In addition, there are often many custodians who work in the

building. In a large high school, there may be as many as 20 individuals who work in different corners of the campus. Consequently, it is not always easy to know each custodian as well as office staff who tend to work in the same areas each day. The key here is the attitude that is demonstrated by you and the teachers when you encounter a staff member in the hall. Simply saying "Good morning" or asking "How are you today?" can go a long way toward making people feel as if they are valued.

Points to Ponder

- How many custodians work in your school? How many individuals do you know by name?
- What is the schedule followed by custodial personnel for your school?

3. We do more than just pick up after people in the school.

Custodians also report that they value people who appreciate the fact that they have skills beyond simply picking up after people. Custodians do much more than clean and engage in maintenance work. It is really important for each member of the school community to demonstrate respect for the many different responsibilities and talents of every other member of the community. Also, remember that in addition to carrying a broom, mop, or toolbox around your school, your custodial staff members also have lives out in the local community. They know people, and they are known and respected by others.

Points to Ponder

- As a principal, you cannot force the teachers and other staff members to pay attention to and respect the custodians. But you can model behavior that will say clearly that you value all of your colleagues in the school. In what ways might you provide evidence that you respect and value everyone who works in your school building?
- Since your custodians may live out in your immediate community, how might you regularly gain their insights into what the concerns are in the local neighborhood?

4. We have ideas beyond simply knowing more effective ways to unclog sinks or wax the floor.

As it was described in the lives of office staff, custodians also possess a great deal of knowledge about extremely important ways to assist you and

others in operating your school more efficiently. As a principal, you can assume that people had a great deal of confidence in your ability to provide leadership for the students in your school. You know a great deal about curriculum and instruction, staff evaluation, school site budgeting, and many other technical aspects of managing an educational organization. How to fix electrical or plumbing problems in a school may not be something in which you received any special training. But having no electricity, or toilets that are broken, has a lot to do with whether your school operates effectively. Learn to rely on the expertise of others, from the counseling staff to the practical knowledge of your custodial staff. You have a considerable amount of expertise around you; use it.

In addition to knowing how to use the technical expertise of your custodial staff, do not forget that many of the individuals who work in that area may have several years of successful prior experience working in your school. They know the idiosyncrasies of teachers and staff members. They know the neighborhood around the school. They know local politics and power groups. And they know students. Often, the custodial staff of a school has had experience with working with students as helpers or part-time employees. Gang members may not stop in to visit in the principal's office, but they are often quite open with people not necessarily viewed as part of the authority structure of a school. You may be surprised at what you can learn from a few short conversations with custodians who see and hear a lot.

Points to Ponder

- Do you schedule brief conferences with members of your custodial team to learn what is on their minds throughout the school year? What do you learn?
- How do you model respect for your custodians in a way to demonstrate your belief that everyone in the school has an important contribution to make?
- Have you shadowed one or more of your custodians to learn what they do each day? What did you learn?

FOOD SERVICE WORKERS

"An army runs on its stomach!" So goes the old saying that describes the fact that when troops are not fed, they don't fight very well. So officers sometime need to do more than worry about battle tactics and strategies. Instead, they need to provide for basic human needs or the humans who work with them will not function very effectively.

Including meal service as part of the responsibilities of public schools is a relatively recent practice. One hundred years ago, schools did not feed

students or teachers. People either brought lunches from home or they went home to have a meal. The days of schools without cafeterias are long gone. Today, American schools provide not only lunch but also breakfast for millions of students across the nation each day. School food service is big business and a regular part of the modern educational landscape.

As an administrator, you are aware that because operating funds are generally provided through resources of the federal government, school food service programs function as separate enterprises within schools. They are not part of the business of running schools, other than the fact that funding must be supervised at the local school district level. Therefore, the food service employees who work in your school are not, strictly speaking, part of your administrative concern. Your school has a designated food service manager who supervises employees and works toward providing students with free (or reduced-rate) and nutritious meals each day.

Despite the official relationship between the administration of your school and the operation of your school's food service program, the people who work in your cafeteria are important components of your school community. Virtually every student in your school will come in contact with the food service workers each day. It makes little difference that food service employees are often part-time workers because they work only during meal service times in your school. They deserve the same treatment as anyone else who serves the children in your school. The people who place food on cafeteria trays are educators in the sense that children observe their behavior and attitudes each day, and these can serve as valuable learning experiences whether they are officially noted as part of your curriculum or not. It is critical that you, as the leader of your school community, do everything possible to demonstrate care and respect for the people who work in the lunch line and who will have contact with the students, teachers, and sometimes community members and parents. As is true of every person in your school, it is essential that you do the following:

- Demonstrate respect for the competence and contributions of each person.
- Understand the unique abilities and skills of each person, regardless of his or her specific role.
- Never forget that the ultimate goal of each encounter that you have with those who work in the school has a potential positive effect on the lives of your students.

Specific Concerns

Like everyone else who is an invisible hero in the school, food service workers have their own issues that deserve attention by the school leader.

1. Please don't ignore us.

While most people in schools (students, teachers, administrators, and many others) come in contact with food service workers each day, the average length of contact is often less than 10 seconds. Cafeteria lines are not designed as possible social encounters; the faster you go through, the better the efficiency of food service operations. But it is unfortunate that there is generally little or no human contact or interaction between the server and person being served in a school lunch line. Instead of just nodding and continuing down to where the next person puts food on the tray, you might occasionally stop and ask a server how they are doing today. And on some days, it might be a good idea to stop in for coffee in the kitchen and simply talk to people about their lives.

2. Don't complain to us if the food isn't what you want.

Most people realize that the food served in a school will not compete for honors associated with four-star restaurants. But the people who prepare food for your staff and students each day do not deliberately prepare bad food each day. They do the best they can with what they are asked to serve. And it all has to be done within the confines of short lunch periods for too many people at a time.

3. Please don't always make us wait at the end of the line.

Several years ago, one of our area food service managers at a very large high school shared an experience he had at another nearby school several years earlier. He had worked as a chef in regular restaurants before he took a new challenge after retirement. His goal as a head cook and manager of a 3,000-student high school was to treat everyone who walked through his cafeteria as a diner deserving full attention from the service staff. Students responded very positively to treatment as people of value rather than simply as a herd of young people eating lunch and making noise and a mess. At the end of the school year, he and his staff prepared a special meal for the entire staff as a treat. He even sculpted a block of ice with the school's motto—a trick he had learned in his days as a private restaurateur. When the principal entered the cafeteria, he pulled the manager aside and told him that after serving the teachers and office staff, the food servers should leave so that they would not interfere with the staff's end-of-the-year festivities. The food service manager had taken special pains to ensure that there was sufficient food so that the entire community could be served and could enjoy each other's company for an hour or so. The lesson to be learned here is that everyone in your school is

a member of the community and, as such, he or she has a contribution to make to the organization.

CHAPTER SUMMARY

This chapter provided many questions you might wish to ponder as a way to assess whether or not you are truly making everyone a member of the school's team. The old proverb that "it takes a whole village to raise a child" is very appropriate for modern schools. There are many caring adults who can contribute to the learning experiences of children. While teachers are expected to be highly qualified by the nature of their state certification or licensure credentials, people who work in offices, as custodians, or as food service workers are often also highly qualified parents who care for their children. Throughout this chapter, the opportunities for these people to participate in the learning communities for the children are noted. Why not invite people who care about student success each day to contribute to the creation of your vision?

POINTS FOR PRACTICE

- As you moved into your role as an administrator, think about the ways you have worked with a secretary or clerk. What did you learn from that experience?
- When you last talked with a security officer, custodian, or food service worker, other than in terms of a required conversation, such as "That parking lot looks like a mess. Can you do something to clean it up before parents get here for the Meet the Teachers Night?" what was the subject of your conversation?
- How many of the invisible heroes in your school do you know by name—first and last?

Remember that creating a true community in your school includes everyone. Never forget those who are known the least but often work the hardest each day.

REFERENCES

Barth, R. (1990). *Improving schools from within.* San Francisco: Jossey-Bass.

Belasen, A. (2000). *Leading the learning organization: Communication and competencies for managing change.* Albany: State University of New York Press.

Kofman, S., & Senge, P. (1995). Creating the learning organization. *The McKinsey Quarterly, 1*(1), 58–60.

Services in
the Community

<div style="text-align: right">**8**</div>

The city of La Casa Blanca is a large city located directly on the U.S. and Mexican border. It is among the largest communities in the region, with a population of slightly more than 700,000 people. Directly across the border is the Mexican city of Granada, with approximately the same population as its sister city in the United States. While the two cities are officially separate entities in two different nations, there is a constant flow of residents back and forth across the national boundaries through U.S. and Mexican customs and immigration posts. The two nations share many common features, not the least of which is extreme poverty. Over the past several census surveys, La Casa Blanca has been ranked as one of the five poorest cities in the United States. Granada is equally impoverished.

The La Casa Blanca City Unified Schools enroll approximately 65,000 students. There are no traditional suburban communities surrounding the city. Other nearby communities in the county stand alone as independent municipalities with a strong feeling of being rural communities, although each town is relatively close to the distinctly urban La Casa Blanca. Bustamente Elementary School is one of 65 preK–6 schools in the La Casa Blanca district. It is an older school in the community, constructed in the early 1950s. Approximately 800 students attend Bustamente. All are Latinos, and a high percentage of the students are enrolled in the Bilingual Education Program.

Juanita Carillo has been the principal of Bustamente for the past five years. She is recognized as an extremely capable school administrator who is also known as being an effective instructional leader whose school always ranks near the top of the district when elementary school student achievement test scores are reviewed each year. While the academic accomplishments of her students give Juanita a great deal of personal pride and professional satisfaction, she often goes home to confide in her husband that she really does not think that she is doing enough for her students.

"My kids have so many problems. Not in being able to read, or do their work in math or science. I have been blessed with one of the best teaching staffs in the state. They really are patient and work many long hours to help the children succeed academically," she shared with her husband Freddie on many occasions. But this realization was not

sufficient to Juanita in terms of her self-assessment as an educator. She would frequently go on by noting the large number of students who came to school looking forward to free breakfast because that would be the first food they had tasted since the free lunch they received at school the day before. She knew that most of the students' parents worked multiple minimum-wage jobs just to find enough money for rent, clothing, and absolute necessities for life. She knew of several students whose fathers regularly beat their wives, often in front of the children in the house. Other students appeared to exhibit signs of abuse at home, but these kinds of problems were difficult to prove as injuries were not readily visible. Others came from homes where drugs and alcohol were abused, and in some cases, there were signs that some of the older children in fourth and fifth grades were using banned substances and a few were already involved in gangs in their neighborhoods. The problems seemed endless.

Finally, Juanita decided that she needed someone with a bit more experience to give her some advice on what to do with the nonacademic issues that were truly destroying the lives of many of her students. She talked to David Stockard, a legendary figure in the La Casa Blanca district. He was by far the single most respected administrator in the district. It was an easy choice for Juanita, a young principal with only a few years of success as an instructional leader now also wanting to make a difference in another way for her students. She wanted not only to help develop minds, but she wanted to have an impact on all aspects of young lives.

Juanita was expecting David to give her a great deal of time coming up with suggestions to be used in dealing with problems of child abuse, use of drugs and alcohol, gangs, broken families, poverty, and all the other problems identified as issues facing the students at Bustamante Elementary. Instead, after listening to Juanita's list of problems facing her kids, David simply looked her in the eye and asked a few simple questions. "Juanita, are you trained as a counselor? A social worker? Do you have a license as a child psychologist?" His young colleague answered "no" to each question. David leaned back in his chair and simply asked quietly, "Then why in the world do you believe you are personally going to be able to handle all of these problems that your kids are facing?"

The session concluded rather quickly after David reached into his desk and pulled out a well-worn laminated page and handed it to his colleague with the suggestion, "If you want, make a copy of this and keep it on your desk for future reference."

Juanita reviewed the sheet of paper and realized that what she was just handed was a document that she knew would soon be on her desk. It contained the names of organizations, offices, and individuals who provided services for children at little or often no cost. Some were state offices, many were part of local government, and some were prominent local experts who gladly provided their services to children in need. There were substance abuse counselors, sports psychologists who specialized in working with disturbed children, special police units, and literally a hundred or more names and phone numbers on a back-to-back chart where David had added a number of personal handwritten comments here and there. "Start calling some of these folks," David said. Juanita walked out of the meeting with a smile on her face.

> **Points to Ponder**
>
> • Do the problems facing students in Juanita's school sound similar to issues that you see in your school? What are some additional challenges that you face?
> • Who are some of the senior administrators in your district who are like David Stockard and might be consulted about issues such as the concerns shared by Juanita?
> • Have you already started to establish a list of agencies to which you could turn if you had special concerns about students? How did you begin to compile your list?

In all probability, you and others in your school do not have the knowledge, skill, or even the desire to try to address the myriad social and psychological problems that face your students each day. Regardless of where your school is located and what socioeconomic status prevails in your school, children today are likely to have challenges not seen in past generations. Some challenges might be handled effectively by simply having an adult listen to a student's concern, with no specific form of intervention required. However, there are all too many cases today where young people are facing multifaceted and complex medical, social, and resulting psychological issues. In these cases, professional intervention may be needed. In summary, an analogy here might be what you have heard about legal issues and school administrators: You may have taken a course or two in school law while you were working on your graduate degree or certification as an administrator, and you may believe that you learned a great deal in that course. However, remember that, in all likelihood, you are not a lawyer. Best intentions as someone who knows a few things about the field of law will rarely be rewarded in a court case. The same can be said about amateurs attempting to provide therapy to children with deep psychological problems.

STUDENTS IN PHYSICAL DANGER

While children in immediate danger of physical harm may be rare in many schools, in other settings, facing danger is a daily reality for children. Of course, the place of danger may be far from the individual classroom or even school. And the source of danger may be siblings, local drug dealers, gangsters, boyfriends or girlfriends of a mother or father, or even a parent or both parents. At times, teachers and staff members realize that children suffer from fears about their own well-being. Favorite

Practical Tips

Tapping Communities for Help

As a caring educator, you know that the main business of your school—promoting student learning—is deeply affected by many conditions that have an impact on student health and welfare. While you are not likely to solve all the problems that students bring to your schoolhouse door, here are a few tips that may help you in serving your students and their families:

- Find out what's there. Talk with staff for recommendations concerning health care clinics, social service agencies, shelters, and other resources that are located near your school and may have programs available to your students and their parents.
- Create a team composed of teachers, staff members, and members of the community to comb the local community for available resources to help your students.
- Make contact with key groups in your community (churches, fraternal organizations, etc.) which are likely to have connections with organizations that could be useful to help students and families needing assistance.
- Make certain to keep your teachers engaged in the search for support for students.

teachers or sympathetic principals can list several situations during their career where they were told by students that they fear going home at night because of threatening circumstances. At times, physical injuries are apparent and corroborate the stories of an injured student.

While the immediate response of many who care deeply about children may be to try to intervene directly on behalf of a child (aged anywhere from 4 to 18), such a practice is not particularly wise. First, it may result in the educator being placed in harm's way. Second, it is important that no allegations be made by a third party to someone named as the person for causing harm. This is, to put it mildly, a situation that needs to be escalated quickly beyond the school walls. It is a serious matter when lives are at risk. You may not wish to contact the police department—unless there is a situation where the immediate safety of the child is a concern (e.g., "Mommy's boyfriend who hit me last night is picking me up, and I am afraid of what he'll do to me today"). Police receive considerable training in investigating such matters; you probably are not ready to step in. More likely, your first call should be to the local office of a state, municipal, or even county office of Child Protective Services (CPS). As an educator, you are expected to follow this procedure by law in most states. You may be told that, if you are a classroom teacher, you are not to contact CPS directly or the police without first reporting the matter to your campus administrator. It may be wise to inform your principal of what you plan on doing on behalf of the child, and you may join with your administrator in reporting a situation. But recall that should a situation escalate and a child be injured seriously or worse, you will be questioned regarding the steps you personally took in trying to protect a child. And the

laws of most states have made it clear that your duty personally is to report issues to the legally specified authorities. Simply sending a note to the principal to ask her or him to do the reporting will not suffice and remove you from the process. It is a legal duty to protect a child by following the law.

Whether you are an administrator or a teacher, keep important numbers for Child Protective Services (or whatever an agency of this sort is called locally) at the top of your resource list.

Points to Ponder

- What is your local district policy regarding a teacher's or administrator's duty of reporting cases of physical abuse (actual or threatened) to legal bodies?
- Have you had the experience, either as a teacher or administrator, of learning of a child in peril because of some sort of abuse either at home or in other situations in his or her environment? What have you done about this?

DRUG OR SUBSTANCE ABUSE

Students are sometimes the victims of actions by others, as the previous description noted. However, there are times when the villains in some lives are the students themselves. Whether it is because of aberrant behavior at school, or through some other method of discovery, school personnel are often able to see with some certainty the fact that students, regardless of age or grade level, are impaired, perhaps through the use of some controlled substance. When such matters are apparent, educators tend to want to seek ways of helping young people with their reliance on drugs or alcohol. Of course, when students appear in class under the influence of medication or liquor, it is a matter for disciplinary intervention. No doubt your school and district have a rather straightforward policy regarding the use of any controlled substance on school property—by students, staff, or visitors. When suspicions exist, the first call from a classroom is likely to be to the principal or an assistant principal because this is often a no-tolerance behavioral offense in most if not all schools. It may solve an immediate problem by ensuring that an offender is not disrupting classes, but it does little to address the real problem: A young person is leading a life with reliance on potentially harmful if not deadly material. Policy dictates one approach to the situation; care for the long-term welfare of a child may call for other strategies to be followed. Of course, in such settings, there are normally counselors who are trained to provide counseling

to students who are addicted to harmful products. But counselors in many schools across the nation report that they have less and less time to intervene with student problems of any sort, let alone substance abuse. In cases where it is clear that a child's welfare is in serious jeopardy, school teachers and administrators, after consulting with parents or legal guardians, may suggest some additional forms of intervention to help students with problems of this nature.

Many communities have fairly comprehensive programs to assist individuals with addiction problems. These may be part of county or city health programs, local hospital treatment centers, and other similar agencies with the expertise to work with and counsel young people (and adults as well) and help with the solution to some addiction problems. Larger school districts may also offer specialized treatment programs as well, but it may be that finding a program under the direction of either local health agencies or private corporations may be much more effective since fear of punishment by the school authorities can be minimized by third-party interventions. Again, regardless of your role in a school, if you find agencies that are willing and able to assist with students working to conquer addictive behavior, whether related to drugs, alcohol, or other causes, keep that phone number high on your list of resources. And get help as fast as it is possible, with the involvement of parents or other authorized personnel.

Points to Ponder

- What experience have you had with students who are clearly under the influence of controlled substances in your school? What have you done in response to this condition?
- What is your district policy regarding such matters?
- What local resources can you identify as potential partners in your efforts to provide support and counseling to substance abusers in your school?
- What types of assistance can you expect from your district administration?

Before leaving this topic, one important issue needs to be highlighted. The assumption underlying the advice above is that the students who may be experience problems with addiction are not involved with the sale or distribution of controlled substances. If that is your concern, you are truly talking about a matter for law enforcement, not of counseling, support, or remediation at this point. Call the police.

STUDENT MENTAL OR PHYSICAL HEALTH

There are students who are not well due to other causes besides addiction to drugs or alcohol. Some of these are chronic conditions which have been diagnosed well before a child comes to school. Treatment is under way by competent health care professionals. While there may be some significant challenges to teachers, administrators, and other staff to act in ways that are supportive of the student's identified needs, these are not typically issues that concern educators in terms of finding additional routes to assist the sick child and his or her family.

Potential problems may lead to school personnel becoming more actively involved in treatment of physical or mental health conditions that may be undiagnosed or untreated by regular professional health providers. In many cases across the nation, parents are unable to provide adequate health care, particularly in the case where chronic problems are present, largely because of the enormous costs. Respiratory, cardiac, and other physical problems are often ignored because initial assessment and diagnosis by competent physicians and nurses does not take place. Often, such problems result in catastrophic outcomes largely because there is no advance warning to guide treatment. Unfortunately, teachers, administrators, and staff who interact frequently with students begin to notice changes in behavior or responsiveness, and because of no regular health care in the lives of children, treatment opportunities are reduced until it is too late for effective yet simple interventions that may be available.

As a school leader, you may have the opportunity to provide valid information and potential treatment paths that may be available for helping students and their parents to locate either low-cost or even no-cost medical care. Developing a file containing the names, locations, and phone numbers of health care facilities open to working with families with limited resources would be a good practice to follow so that, in the event that a child's parents are reluctant to seek medical care because of cost, you may be able to offer some alternatives. In the meantime, it is important to document all cases where it may appear to professional staff that there are reasons to suspect physical problems (e.g., lethargic behavior; sleep during the day; wincing frequently when sitting, standing, or walking; and many other items that may trigger alarm signals in staff).

The same suggestions that are offered here for physical health issues are appropriate for mental health intervention. School personnel are able to witness students in a variety of situations and may suggest that testing be carried out to diagnose such learning disabilities due to autism or attention deficit disorder. Doing so could be an important first step toward

providing students with special assistance. In many cases, there is still a stigma that makes families reluctant to admit that a child may need help.

The purpose of suggesting that school leaders and others be attentive to signs of situations calling for professional intervention for some students is not an effort to create meddling interference in personal matters. And there is no intent to require educational personnel to engage in professional diagnoses with medical certification.

Being prepared to offer suggested interventions on behalf of student health concerns is not a matter of meddling or practicing medicine without a license. Above all, considerations of possible health issues is a learning matter. If students are having medical problems, they will not be able to participate effectively in the educational program. And if there are mental health problems, there will likely be serious limitations of a person to learn in a traditional school environment. Simply noting behavioral patterns which may or may not be related to professional diagnosis or treatment may provide insights into a student's condition—or lack of a need for any serious concern. And being prepared to assist with information about available resources is anything but an unfriendly or unprofessional activity.

Points to Ponder

- What experience have you personally had in identifying appropriate treatment options for providing health treatment for a student?
- Have you ever offered advice to parents or caregivers regarding opportunities for professional intervention for possible health problems for students? If so, what advice would you give to other educators about the experiences that you have had in this regard?

FAMILY TURMOIL

As most educators are aware, the days of *Ozzie and Harriet* and the perfect lives of families of television are no more. Twenty years ago, most students in most teachers' classes had two parents at home, and the two parents at home had been married to each other for several years. They may or may not have been the biological parents of the child, but they represented a mostly positive and unified foundation that were viewed by their children as *Mom and Dad*.

Things have changed drastically in more recent years. Teachers report the issue of parenting is one of their greatest frustrations. The majority of students today have either a mother or father with them at home, but rarely

both. Interestingly enough, increasing numbers of classroom teachers understand this reality because, over the past 20 years, more and more teachers have come from single-parent homes. But the frustration continues as teachers seek to develop relationships with parents that will enhance the learning in school. Single-parent homes are not necessarily a problem in themselves. But in such cases, it may mean that the custodial parent cannot invest the time and attention in the children at home and still maintain the professional career path that may be needed to provide for the family.

Perhaps an even more distracting family situation for more students is not necessarily the composition of the parent unit, but rather behaviors of family members at home. Often, substance abuse may be present. The mother may be an alcoholic while the father is a drug abuser. Or perhaps a parent is in trouble consistently with the police. Sending students to foster homes or even to live with a grandparent or an aunt or uncle is hardly a solution that will provide youngsters with the kind of stability that will assist them in developing their study habits.

There are also cases where students may be suffering from a sense of abandonment by their parents. Consider, for example, a case that we discovered of a young primary school student who was included in a large population of students referred to locally as "Katrina Kids." These were children who had been relocated to the area after the turmoil created by the destruction of local services caused by Hurricane Katrina in the Gulf Coast region. The little boy was sent by his mother to stay with his grandmother. Finally, it was clear that the child had been abandoned by his mother and simply sent away to a rather elderly and ill woman who had tried to take care of a young child needing more attention than a senior citizen living on a limited fixed income could provide. It was probably inevitable that the child would eventually start to demonstrate behavioral problems at school. Until the teachers and administrators at his school became aware of the circumstances surrounding the young boy's life, he was classified as a discipline problem, with problems that were left to be dealt with at home. And in this case, there were no resources at home.

Points to Ponder

- What is the profile of parenting in your school? Do most of your students come from single-parent households?
- What is the impact of single parenting on the learning needs of students?
- What are some of the dysfunctional family activities that you have witnessed, and what is the effect of those activities on students?

RETURNING TO LA CASA BLANCA
SCHOOLS AND BUSTAMENTE ELEMENTARY

The issues in the many American schools that are similar to the school depicted in the opening scenario are seen in many settings across the nation. Poverty is significant, and the social realities of many schools and districts are likely to be much more powerful predictors of student success than any educational concerns. When children are sick, abused, or using illegal substances, little learning will occur; in many cases, the school is somewhat powerless in its efforts to overcome the problems that exist. Parental involvement is one of the most effective strategies that can be used to strengthen student learning. But in many parts of the country, parents are anything but involved with schools in an effective way.

If schools are to meet the challenges present in a world where there is an ever-increasing number of students at risk each year, it will become increasingly important for thoughtful and caring educational leaders, such as the principal in the case of Bustamente Elementary School, to define their roles in large measure as resource or information providers to students and their families. School principals are not social workers. But they need to find ways to match student needs with social service agencies. They need to keep lists of resources at hand.

CHAPTER SUMMARY

This chapter reviewed some of the most frequent problem areas that impact the lives—and ability to learn—of students enrolled in schools. In each case, it was noted that there are strategies and resources that are often readily available for families to utilize. It is understood that schools cannot compel students or their parents to seek counseling support, or even medical treatment when needed. But at least the school can work to ensure that, if needed, appropriate community resources are identified as ways to assist parents and their children to find help when needed.

POINTS FOR PRACTICE

Admittedly, principals and other educators have many things on their plate today, and no one has figured out an effective way to give us more time to respond to all of the expectations that are held for schools. And what is proposed in this chapter is, in a sense, asking you to go the extra mile with the services that you should provide to students and their families. But if you are

working with students who are addicted to drugs, in dysfunctional homes, sick, hungry, or facing many other similar challenges, you will be facing students who are being blocked from learning. Taking care of the whole child is something that school leaders need to address through attitudes and actions.

- Many students must be given extra support if they are to learn in classrooms.
- While principals are not social workers, they are leaders of learning for students. As such, they need to discover ways that can help all students achieve their goals despite experiences that might inhibit learning.
- As principal, you also have the opportunity to assist all members of your community to develop new ways of addressing issues that often face students by becoming aware of a variety of community resources that can be tapped to help students and their families.

Support From Central Administration

<div style="text-align: right; font-size: 2em;">**9**</div>

Sylvia Friedman was considered one of the best teachers in the Walden Falls Local School District. For 18 years, she taught children from kindergarten through Grade 6 in four different schools in the district. The reason that she changed schools as often as she did was that, as a recognized master teacher, she had been recruited as a key member of the staff in three new elementary schools that opened after her first five years as a teacher at Kelly Brewster Primary School.

However, as her career continued and Sylvia won increasing recognition for her work in classrooms, she secretly began to want new challenges in her professional life. She never really admitted it to many colleagues, but she always had a strong interest in eventually leaving the classroom. She was confident in her skill as a classroom teacher, but she also knew there were some bigger issues that affected students and these could no longer be handled from the level of a single teacher. She knew that true change had to take place with the authority and influence derived from a position as an administrator. As a principal, she believed she would have the voice needed to make changes in the ways in which schools addressed such noneducational issues as students feeling alienated from others, lack of care for many needs of students, isolation by teachers, and other characteristics of schools that have earned criticism for years. For three years, she took classes leading to state certification as a principal, and last spring she applied for the open principalship at Osgood Conklin Memorial Elementary School. She received word almost immediately that she was on the short list of applicants, and about two weeks later, she got a phone call from Dr. Allison Wittenauer, who invited her to step in as the new Conklin principal as of July 1. She accepted the offer, the school board approved the appointment, the changes were announced in the newspaper, and Sylvia received cards, gifts, and the best wishes of many colleagues across the district who wished her good luck with her new job.

Soon after she officially got the keys for her school, Sylvia was visited by Dr. Wittenauer, who wanted to see how her new principal was settling in. She also wanted to have a

conversation with the new principal concerning her personal vision of where the school should be heading. That was old ground covered in the interviews for the job, of course, but now the superintendent was asking not only what Sylvia wanted, but more important, what the district might be able to do for her. It was a question that took Sylvia a bit by surprise since she never really gave much thought to what she needed outside of her school to help her move forward with what she believed would be an appropriate direction for Osgood Conklin. During her interview for the job, Sylvia had said that her vision for the school was that, in addition to it doing well in terms of student achievement scores, she wanted to develop a spirit of community that would change the culture of the school. She wanted to create a sense where every teacher focused all of his or her energy on ensuring that the needs of students were the driving force for all that was done. She hoped that parents would feel comfortable to contact teachers about concerns, and that the neighborhood surrounding the school would feel proud of the fact that the school was an integral part of their life. And she wanted to see unity among all members of her staff—teachers, clerks, custodians, and everyone else who worked in the school—sharing a sense that they were all on the same page with regard to helping children.

"I really liked the sound of what you were saying because I have a similar vision for how the whole district should function as a community," the superintendent noted. "But in order for that to happen, I know that change must occur on a school-by-school basis." She went on to explain that some schools acted as if they were one big happy family and that the needs of students were clearly driving all activities. Teachers treated each other and all people with whom they worked and interacted as true colleagues. On the other hand, there were other schools where the word *cocoon* really summarized exactly what was going on; teachers rarely talked with each other about professional goals and activities, non-certificated staff had their own culture, and parents rarely entered the school unless they were summoned to talk about problems with individual teachers. Not surprisingly, the latter group of schools tended to be the ones with some of the lowest achievement scores in the district each year.

The superintendent concluded her observations about desire to create community on a districtwide basis by telling Sylvia, "I'll do what I can to help you with your vision at Osgood Conklin, but I wish we could find some way to get the word out across the whole school system. What can we do to help each other and act as we both want others to act so that we can really devote energy to what we hope for our students?"

After the superintendent left, Sylvia realized that she had just gotten both an invitation to seek help from the central office, but also a strong suggestion that she needed to keep moving forward with her vision of developing community in her school. She had a lot of good ideas for what she wanted to see happen at Osgood Conklin Elementary School, but she also wanted to see better things happening for students across the school district. She felt good to know that she had an important ally in the superintendent, but the principal knew that superintendents come and go, and Dr. Wittenauer was rumored to be looking at several other opportunities in larger and more prestigious school systems in the state. She heard words of support from her boss, but the principal had to proceed with her plan to move forward with her vision.

Points to Ponder

- What would you do if you received the verbal support of a superintendent to go forward with a project that she/he approved, but you were uncertain of continuing support in the future?
- Who are the key actors in your school district that need to be recruited to help you with any change effort in your school?
- What departments or groups should be kept informed of your project?

One of the great frustrations of any principal who seeks to bring about meaningful change in a school is the recognition of an often-cited fact that any effort to bring about change generally takes three to five years to achieve (Daresh, 2005). And for a variety of reasons that we consider later in this chapter, change in schools is often more difficult to achieve than it might be in many other organizations. It makes little difference of the magnitude of a change, it takes time to prepare the people who will ultimately be responsible for bringing about the change to accommodate new policies, practices, and at times philosophies that are required for a change to be adopted successfully.

And a major part of change involves change in policies in most organizations. Schools are components of hierarchically structured social organizations known as school districts or systems. Because of this, even minor modifications in one school building have probable implications at all or most other schools in a district. And because of the hierarchical nature of districts, it is critical that school leaders recognize the importance of laying a foundation for their efforts with key personnel and offices in the school district's central administrative offices. This critical step in leading a school toward the adoption of beliefs and structures characteristic

Practical Tips

Working With District Leaders

School leaders have had a great deal of experience with trying to ensure that they have laid out support mechanisms for the efforts that they wish to implement in their schools. And some of the most successful experiences made use of these tips:

- **Keep your school board informed of your success.** Your school board holds the keys to resources and other means of supporting your plans. Keep the group informed.
- **Review relevant research.** Search sources of research findings to support your work. At some point, you will be challenged to provide proof of the value of whatever changes you seek to make.
- **Talk with your boss.** Never surprise your superintendent.
- **Cultivate supporters at the district level.** Keep all relevant parties in the central office informed of what you are doing in your school.

of communities is clearly something that needs support from many people throughout the district organization.

In this concluding chapter, we consider the nature of bringing about changes in schools and the ways in which it is critical for any school leader to ensure that a proper foundation has been established with key policymakers and organizations in the school system to ensure that once a shift begins, it will have an opportunity to develop into effective long-term practice.

WHAT MAKES IT HARD TO CHANGE SCHOOLS?

John Lovell and Kimball Wiles (1983) recognized several frequent barriers to organizational change in schools that lead to push back:

1. *Lack of commitment to goals.* If teachers or staff members do not understand or accept the goals of the school (and leader), they will not endorse the change. The suggestion here is for you to ensure broad-based involvement throughout a school as specific goals are developed.

2. *Inadequate feedback.* Teachers claim that they frequently lack concrete information and evaluative feedback concerning performance of proposed changes. Teachers with such feelings demonstrate tension, anxiety, and low morale that often cause people to withdraw from involvement and avoid any perceived risks required for change.

3. *Attitudes toward or values about the proposed change.* If people start out with a negative view of a proposed innovation, that attitude will likely persist.

4. *Satisfaction with the status quo.* Teachers demonstrate the same reluctance to modify their behaviors that others do. The old saying "If it ain't broke, don't fix it" applies equally to educators who are not always convinced of the need to change what they have been doing in the past.

5. *Inadequate skill development.* People will not want to become engaged in an innovation if they believe they are going to fail because they do not have the skills needed to carry out a new program or approach.

6. *Strong vested interests in the status quo.* People may believe that they will lose something for which they have worked if changes are made in the system around them.

7. *Threat to individuals.* People fear new situations. Some resistance to innovation is likely if people feel that the new effort will make them feel unprepared or even incompetent.

8. *Static organizational role structure.* Organizations often lack needed leadership that will bring about needed change. Principals must be leaders who promote and support change. They cannot serve as barriers to the development of more effective ways of addressing the needs of students.

9. *Threat to officials in the organization.* Administrators—particularly in central administrative posts—often are less than supportive unless they feel as if they are the source of new ideas.

10. *Lack of organizational support.* There is no question that, if the central administration of a district does not support a new practice or new ideas, the practices and ideas may be launched, but continuing implementation may not be possible without support from "downtown."

Points to Ponder

- What additional issues tend to inhibit change in schools?
- If faced with any of the 10 conditions noted above, or other inhibitors to needed change in your school that you might identify, what would you do to reduce the impact of these factors?

There are, of course, other impediments to change in schools. However, the ones identified above may have particular importance to consider while you try to lead your school from being Cocoons, or Competitive, or Congenial, to truly Collegial. It will only be that type of transition and change that will result in the creation of the kind of community perspective that is likely to be the foundation for more effective learning opportunities for students.

The last three factors that are said to inhibit change have particular potency to block an effort to turn a school around to becoming a true community of learners. If you are reading this book as a principal who is interested in moving your school toward becoming a learning community, this issue may not be relevant to you. But other schools without leaders interested in changing the status quo where teachers work in isolation from each other, staff members are not involved in education, and parents

and community members are left out of the loop in terms of involvement in a meaningful way in schools are likely to have a hard time coalescing into organizations where the assumption is made that schools will be better if they function with a unified approach to supporting learning. As it is true with any other change activity, leadership is the key ingredient to making good things happen.

The assumption that change is often blocked by the sense that any change may be viewed as a threat to officials in the organization is a serious concern to the adoption of a sense of community in schools, particularly if it makes individual schools more powerful than the school district organization. There is a longstanding tradition in many districts that implies that all change and innovation in an organization must come from the top down. Changing schools to become communities is indeed a school-by-school change.

Lack of organizational support is indeed a potentially major problem in the life of any effort to promote change in schools. In the next part of this chapter, we explore some of the key persons that need to be at least kept informed about the progress you are making with an attempt to change traditions and cultures into ways in which there can truly be schools which focus on the real needs of students as people, not simply test takers.

KEY PEOPLE TO KEEP INFORMED

The problem with any kind of educational innovation, whether it is a new program, new curriculum, new administrative structure, or in this case, a whole new kind of school culture, is that because district leadership turns over so quickly in many districts, the prized effort of one superintendent is not the favorite project of his or her successor. As principal, this is where you must continue to rely on other administrators in the central office so that, even when a key leader leaves, there is still some continuing support for the work of a school that is being directed toward becoming more of a community. Remember that, in some districts, the next superintendent comes from the ranks of assistant superintendents already in place. Even if there is an effort to ensure that the district receives new blood by hiring an outsider as superintendent, there will likely be a period of time when an interim superintendent from within the district serves on the school board. Regardless of who is selected or might be selected in the future, you must keep up the promotion of your school so that its reputation becomes so strong that it cannot be easily changed by a newcomer. If this sounds like a suggestion for you as

principal to become a promoter and cheerleader while at the central office, so be it. It works. The quality of some schools often becomes so strong in people's minds that no one will mess with the place. That's the goal you have to achieve for your vision. Parents and community members who are advocates for your work are always the best spokespersons for you and your school community. Few educators enjoy playing political games. But it is essential to recall that games can at times have very positive effects on important goals. And key role players are parents and local community representatives who are your supporters in terms of the development of community for your school. Enlist their support.

Points to Ponder

- If your current superintendent were to leave your district, who are some likely current administrators who might be asked to serve as either the acting or interim superintendent of schools? What is their current relationship with you and your school? How aware do you believe these people are concerning your effort to promote community?
- What key personnel at the district office may need some additional information about your vision for the school?

Human Resources Personnel

As we discussed earlier in this book, a person's philosophy must be consistent with the notion of community building if that vision is to be achieved. It is virtually impossible to guarantee that every teacher and staff member hired for a school will come forward as a true believer in your vision. After all, schools often have high needs for certain teaching backgrounds and expertise. Math, science, special education, and bilingual education are areas that quickly come to mind. It is hard to turn away a qualified teacher who has clear expertise in teaching math simply because he or she is not tuned into the notion of working as a part of a learning community. Having said this, it is still possible to alert key personnel in the Department of Human Resources and personnel in your district what your school vision is to be in terms of trying to build a sense of community. You may be reluctant to send such messages to the central office, but the fact is, most human resources professionals are glad to receive some guidance from the trenches regarding the desired characteristics and backgrounds for different schools. Do not be bashful about identifying your wish list for teachers and staff members.

When you are spreading the word about ideal candidates to work in your school, make certain that you practice what you preach by talking with those who are responsible for selecting and hiring (and placing) non-certificated staff. After all, if you believe that custodians, secretaries, and cooks are part of your community, you need to do what you can to bring people who accept your school's vision into the community.

Points to Ponder

- If you had to list some of the characteristics that you would see in a teacher hired to fit in with the newly emerging culture of your school as a community of learners, what would they be?
- If you could hire staff, security, custodial, and food service workers with the attitudes and skills to fit in your school as it develops to meet the vision and mission that you and your colleagues have created, what would you look for?
- At what point in the hiring process in your district do you believe it would be most effective to identify your concerns about new staff and teachers?
- How might the Personnel or Human Resources Department be helpful to you in removing some staff members who do not support the creation and maintenance of your school's vision?

School Board

Although we suggested earlier that a principal who wants to protect a certain vision for a school must engage in political behaviors on occasion, we are not promoting the idea that school leaders must engage in partisan politics. This is especially true with regard to dealings with the school board of your district. The school board, as the legal policymaking body of a school district, can be the most important connection to make. If it is true that superintendents come and go, then it is essential that your vision of a school community gains a status that is, at least for a few years, protected not just as a favored program by administrators, but in written policy. If, for example, the board can see the value of what is happening in your school because parents, staff, community members, teachers, and administrators are functioning in a collaborative arrangement, it is more likely that support will continue long after individual personalities (including you) have left center stage.

Working to garner support from the school board is highly dependent on the culture and history of each individual school district. In some cases, the superintendent may make it clear that no principal

should ever approach an individual school board member as a lobbyist might try to curry favor in a legislature. Superintendents often get quite nervous when they see their employees (i.e., principals, teachers, and others who work in a school district) petitioning board members for special favors. However, there are some school districts with long histories of board members actively seeking input from people outside the superintendent's office. The same is true if your school district has board members elected from specific areas like precincts. If you work in such a district, make sure that the great things that you are doing at your school are made known. School systems with such a policy generally have made it known that board members want to spend time at their schools in their areas. Brag.

The reasons for talking with board members should be understood in all cases as not seeking an opportunity to complain about the superintendent, seek pay raises for administrators, or otherwise complain. Rather, if you are committed to the creation of a productive and creative climate where all people are working toward the improvement of student learning, it is important to alert decision makers and policymakers to the good things that are happening. Regardless of changes of central office administrators, such good news can be remembered for a long time in a school district. Make certain to do your homework and be prepared to talk about the value of changing culture—an activity that is difficult to achieve, but one which takes virtually no extraordinary amount of resource support from the system.

Points to Ponder

- Describe the formal or unstated policy in your district with regard to principals of individual schools talking to board members. Is this a practice that is widely accepted, or is there a possibility of bringing about change?
- What would you tell a meeting of your school board if you were invited to make a formal presentation about the development of a climate and culture of collaboration?
- What policies or practices in your district might need to be reviewed if there were a serious district commitment to support the creation of community cultures? For example, in some districts, all teacher and staff appointments are made at the central office and then communicated to the individual schools. Is it possible to empower individual school communities to take a greater role in this very critical process? Why or why not?

CHAPTER SUMMARY

In this chapter, the importance of maintaining a positive relationship with your central district administration is noted. It is critical that whenever a principal works with staff to initiate any changes at the individual school site level, that change is understood by all key players in the organization. Planned change, as noted here, is a process where teachers and staff are often powerful critics of any effort to modify "what we've always done around here." And remember that changing the school's culture so that it becomes a true learning community is not a small issue. New attitudes must be created and interactions among staff, parents, and community members have to be created.

In addition to the need to ensure that communication channels are open within your school, it is also essential that support away from your campus must exist. Some principals assume that if a superintendent gives a nod in favor of their work, the creation of understanding has occurred at the district level. However, as educators know, superintendents are likely to change and move to other districts rather unpredictably at times. Getting a thumbs-up from a single player, even the CEO, is no guarantee of ongoing endorsement for what you may wish to accomplish. As a result, we noted other critical players who need to be informed at least of what your vision is all about. And the importance of clearly articulating why what you do will help the quality of student learning is critical. To that end, we strongly recommend that ongoing information be provided not only to the superintendents, but to other key central office administrators, one of whom may be called upon to serve as an acting CEO if your current superintendent departs suddenly. In addition, two other groups must be kept informed— not necessarily for their approval, but rather because their awareness of new activity can be critical to your success. As a result, we identify the Human Resources or Personnel Department and also the school board as the official policymaking and governing body for your district

POINTS FOR PRACTICE

The following are specific actions which should enable you to make certain that your efforts at changing former practice and attitudes in your school will endure, even if key leaders (including you) leave the scene.

- Talk to the key leadership of the school district. At times, this talk might focus on seeking permission to try certain things, or it may be because you need additional resources. Regardless, the need to let higher-ups in on your school plans will always be appreciated.

- Think strategically when building a base of support. Assume that changes in key personnel can happen with little warning, so having a contingency plan that defines "who you should talk to in case . . ." is absolutely essential to avoid the natural tendency in many organizations—particularly schools—to return immediately to former practice if endorsement is not received at the district level.

REFERENCES

Daresh, J. C. (2005). *Beginning the principalship* (3rd ed.). Thousand Oaks, CA: Corwin.

Lovell, J. T., & Wiles, K. (1983). *Supervision for better schools* (5th ed.). Englewood Cliffs, NJ: Prentice Hall.

Index

Abandonment, parental, 117
Achievement testing, 81–84
Adaptation, 48
Administration, central, 121–131
 barriers to school change, 124–126
 informing key people, 126–129
 scenario, 121–123
 working with district leaders, 123
Amish children, shooting of, 27–28
Assistant superintendents, 126–127
Autonomy, 48
Axiomatic Theory of Organizations, 46

Barker, Joel, 18
Barriers to school change, 124–126
Barth, Roland, 93–94
Blame, 43–44
Bolman, Lee, 48–49, 62, 70
Breaking Ranks (National Association of
 Secondary School Principals), 32–33
Bullying, 79–80

Case study (external environment),
 59–73
 analytic framework, 62
 historical thumbnail, 62–63
 human resource frame, 66–68
 political frame, 68–70
 scenario, 59–61, 72
 structural frame, 64–65
 symbolic frame, 70–71
Change:
 barriers to, 124–126
 promoting, 27
Chicago Public Schools, 33
Child Protective Services (CPS), 112–113
Classified staff. *See* Support staff
Climate. *See* Culture and climate
Closed organizational climate,
 47, 47 (table)

Cocoons, in Four Cs Model, 51
Cohesiveness, 48
Collaboration, culture of, 35–36
Collegiality, in Four Cs Model, 53–55
Communication, 22, 48
Community:
 concerns, 85–87
 definitions, 26–28
 keeping informed, 127
 operationalizing, 33–37
 role of, 10–11
 school effectiveness concerns, 85–87
 values, 87
Community building, foundations for,
 25–39
 change, promoting, 27
 collaboration, culture of, 35–36
 definitions of community, 26–28
 operationalizing community, 33–37
 results, focus on, 36–37
 scenario, 25, 37–38
 schools as learning communities,
 31–37
 Senge, Peter, on, 28–31
 student learning as primary goal,
 34–35
 values shared by learning community,
 31–32
Community services, 109–119
 drug/substance abuse, 113–114, 117
 family turmoil, 116–117
 scenario, 109–111, 118
 student mental or physical health,
 115–116
 students in physical danger, 111–113
 tapping communities for help, 112
Competitiveness, in Four Cs Model, 52–53
Congeniality, in Four Cs Model, 51–52
Counselors, school, 113–114
CPS (Child Protective Services), 112–113

Culture and climate, 41–58
 described, 43–45
 development of culture and climate
 research, 45–49, 47 (table)
 educational platform excerpts on
 school climate, 5–6
 Four Cs Model, 51–55, 54 (figure), 57
 organizational climates, 47, 47 (table)
 reshaping school culture, 44
 scenario, 41–43, 55–57
Custodial staff, 101–104

Deal, Terrance, 48–49, 62, 70
Decision making, broad-based
 involvement in, 9
Drug abuse, 113–114, 117
Drug dealers, 114
DuFour, Richard, 34–35, 36–37

Educational platforms:
 about, 3–6
 community member roles, 10–11
 decision making, 9
 excerpts, 5–6
 learning community development, 7–8
 normative use of, 7–11
 parental involvement in school, 8
 scenario, 1–2, 11
 support staff involvement, 9–10
Effectiveness, school, 85–87
Environment, external, 59–73
 analytic framework, 62
 historical thumbnail, 62–63
 human resource frame, 66–68
 learning local landscape, 62
 political frame, 68–70
 scenario, 59–61, 72
 structural frame, 64–65
 symbolic frame, 70–71

Family turmoil, 116–117
Feedback, inadequate, 124
Fifth Discipline, The (Senge), 29–31
Food service workers, 104–107
Four Cs Model, 51–55, 54 (figure), 57
 Cocoons, 51
 Collegiality, 53–55
 Competitiveness, 52–53
 Congeniality, 51–52
Frames, organizational, 48–49. *See also*
 Environment, external

Gates, Bill, 10–11
Getzels, Jacob, 46

Goals, 34–35, 48, 124
Guba, Egon, 46

Hage, Jerald, 46
Halpin, Andrew, 47, 47 (table)
Health:
 mental, 115–116
 organizational, 48
 physical, 115, 116
Health care facilities, 115
High school size, 32–33
Historical thumbnails, 62–63
Human resource frame, 49, 66–68
Human resources personnel, keeping
 informed, 127–128
Human resource utilization, 48

Innovativeness, 48

Leadership, 6, 125–126
Learning:
 about local landscape, 62
 as primary goal, 34–35
 student, 34–35, 81–83
 team, 31
Learning communities, 7–8, 31–37
Learning disabilities, 115–116
Lovell, John, 124–125

Mastery, personal, 30
Mental health intervention, 115–116
Mental models, 30
Miles, Matthew, 48
Mission statements, 16, 20–21.
 See also Vision
Molestation, 80
Morale, 48

National Association of Secondary School
 Principals, 32–33
Non-certificated staff. *See* Support staff

Office workers, 97–101
Open organizational climate, 47, 47
 (table)
Organizational climates, 47, 47 (table).
 See also Culture and climate
Organizational frames, 48–49. *See also*
 Environment, external
Organizational health, 48
Organizational structure, 46, 125–126
Organizational support, lack of,
 125, 126
Outcomes, 46

Parents:
 as advocates, 127
 concerns of, 78–84
 involvement in school, 8
 return on their investment, 83–84
 safety concerns, 78–81
 student learning needs and, 81–83
Physical danger, students in, 111–113
Physical health, student, 115, 116
Police department, 112, 114
Political frame, 49, 68–70
Political games, 126–127
Power equalization, optimal, 48
Problem-solving, 48

Realty firms, working with, 87
Respect, 100, 103
Responsibility without authority, 95–96
Results, focus on, 36–37

Safety concerns, 8, 78–81
School boards, 128–129
School climate. *See* Culture and climate
School counselors, 113–114
School culture and climate. *See* Culture
 and climate
School districts, hierarchical nature of,
 123–124
School effectiveness, 85–87
Schools, small, 32–33
School secretaries, 97–101
School Town Meetings, 78–79
School violence, 78–79
Secretaries, school, 97–101
Security concerns, 8, 78–81
Security staff, 94–97
Senge, Peter, 28–31
Sergiovanni, T. J., 3, 4
Sexual abuse, 80
Single-parent homes, 116–117
Skill development, inadequate, 124
Small schools, 32–33
Social Systems model, 46
Starratt, R. J., 3, 4
Statement of personal values, 4
Status quo, 124
Structural frame, 49, 64–65

Structure, organizational, 46, 125–126
Students:
 achievement, 5
 leader's image of, 5
 learning by, 34–35, 81–83
 mental or physical health, 115–116
 in physical danger, 111–113
Substance abuse, 113–114, 117
Support staff, 91–107
 custodial staff, 101–104
 food service workers, 104–107
 importance of, 92–94
 involving, 9–10, 93
 office workers, 97–101
 scenario, 91–92
 security staff, 94–97
Symbolic frame, 49, 70–71
Systems thinking, 29

Teachers, leader's image of, 5
Teacher-student relationships, 5
Team learning, 31
Testing, achievement, 81–84
Togetherness, sense of, 50

Values:
 change and, 124
 community, 87
 learning community, 31–32
 personal statement of, 4
 See also Educational platforms
Victorian Ministry of Education
 (Australia), 31–32
Violence, school, 78–79
Vision, 13–24
 articulating, 17–19
 building shared vision, 31
 communicating to others, 22
 developing, 16
 implementing, 19–21
 mission statements, 16, 20–21
 monitoring, 21–22
 scenario, 13–15, 23

Welch, Jack, 10
Wiles, Kimball, 124–125
Work behavior, collective, 50